THE PORTRAIT PHOTOGRAPHER'S

Guide to Posing

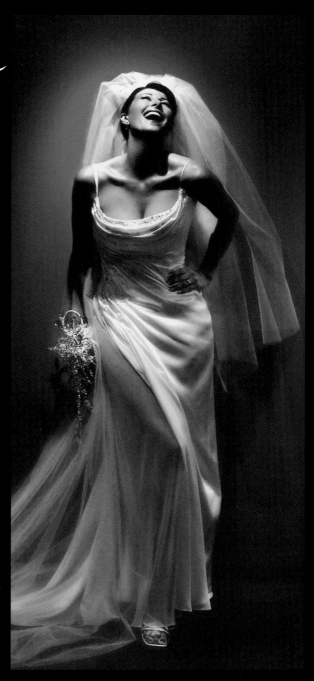

BILL HURTER

AMHERST MEDIA, INC. ■ BUFFALO, NY

ABOUT THE AUTHOR

Bill Hurter is the editor of *Rangefinder* magazine. He is the former editor of *Petersen's PhotoGraphic*, and is a graduate of Brooks Institute of Photography, from which he holds a BFA in professional photography and an honorary Masters of Science degree. He has been involved in professional photography for more than twenty-five years. Bill is also the author of *Portrait Photographer's Handbook, Group Portrait Photography Handbook, The Best of Wedding Photography, The Best of Portrait Photography, The Best of Children's Portrait Photography, The Best of Wedding Photojournalism,* and *The Best of Teen and Senior Portrait Photography,* all from Amherst Media.

Front cover photograph by Anthony Cava.
Back cover photograph by Deanna Urs.
Title page photograph by Yervant Zanazanian.

Published by:
Amherst Media, Inc.
P.O. Box 586
Buffalo, N.Y. 14226
Fax: 716-874-4508
www.AmherstMedia.com

Publisher: Craig Alesse
Senior Editor/Production Manager: Michelle Perkins
Assistant Editor: Barbara A. Lynch-Johnt

ISBN-13: 978-1-58428-126-9
Library of Congress Control Number: 2003112482

Printed in Korea.
10 9 8 7 6 5 4 3 2 1

TABLE OF CONTENTS

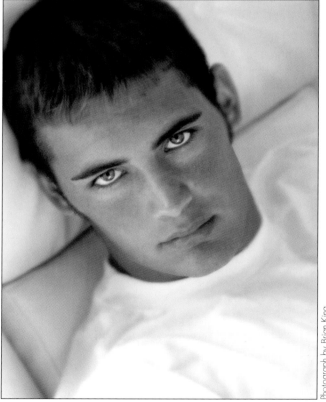

Photograph by Brian King.

Photograph by Joe Buissink.

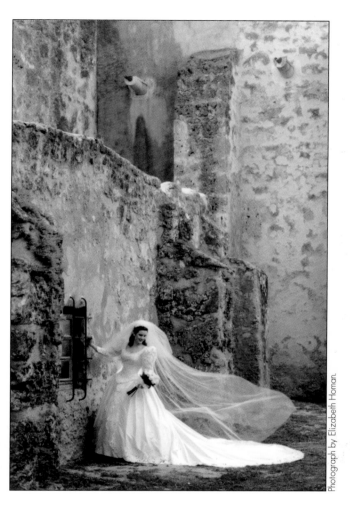

Photograph by Elizabeth Homan.

INTRODUCTION
THE CHANGING NATURE OF POSING

Just as the mythological Narcissus peered down into a pool of water and saw an image of himself as a youth whose beauty was dazzling, so the recipient of a fine portrait session sees his or her likeness similarly—idealized and beyond comparison. Although portraiture is an ancient art of capturing a likeness, it goes beyond that definition to include those characteristics unseen by the eye but experienced through the emotions. Qualities of strength, honesty, vulnerability, and character are imparted in a portrait through the elements that define the art form, such as lighting, composition, and above all, posing.

Great portraiture has captivated viewers for centuries. It is not their literal qualities—like the length or shape of the nose or the width of the forehead—that causes great portraits to be beloved, but rather the stirrings of imagination they impart. Award-winning Australian photographer David Williams articulates his feelings upon seeing a captivating portrait by 19th century French artist Gustav Courtois of a beautiful young woman in a Chinese dressing gown against a textured gold background. "She seduced me. I could imagine her laughter, her

◄ The long wisp of hair, the off-center composition—everything about this image is compelling. David Williams made this portrait of his niece at eighteen, a young lady he describes as "a fresh beauty with a quiet and trusting innocence." He titled the image *My Flying Heart*. The image was made with a Fuji FinePix S2 camera and a Sigma EX APO 70–200mm f/2.8 lens with a single studio flash. The final print was made on an Epson Stylus Photo 1290 printer at 1440dpi using English Perma-jet Portrait Classic 300gsm paper.

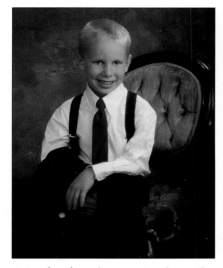

▲ His first formal portrait? Perhaps. The brand new JC Penney shirt, right out of the package, the attention to detail in his unfamiliar formal clothing, the look of exuberance, the decidedly masculine posing—this portrait by Frank Frost is symbolic of the special power and importance of the formal portrait—both to families and individuals. Photo by Frank Frost.

► *Quinceañera* is the Spanish name for a debutante. Literally, it means "girl turning fifteen." In Miami, master photographer Robert Lino has made a full-time job out of photographing these young women at this special time in their lives. The poses are decidedly formal and "old world," honoring the great posing traditions of the past.

passion. Who was she? What were her thoughts, attitudes, tastes? What life did she have? How long did she live? There were so many questions . . . but then, in the nature of fine portraiture through the ages, there was an imagined rustle of fabric, a sense of perfume—the gentle brush past of a long-departed soul, and she was gone."

Gifted portrait photographers have the ability to create lasting images of people that are enjoyed by generations of viewers. Don Blair, a legendary portrait photographer, describes his portrait skills as an offshoot of his personality. "To me," he says, "everyone is beautiful. It is my job to bring out that beauty and capture it." He continues, "This pursuit . . . has been a lifelong obsession—an endless journey upon which I travel each working day. I hope it never ends!" In Blair's carefully crafted portraits, one sees a nearly perfect moment frozen in time in which the person's beauty and character are affectionately revealed.

David Williams takes this notion a step farther. "My recent photography of children, done in a documentary style, demonstrates to me the power and duration of portraiture. What I have realized is that I am not making photographs just for the parents of a child. I have come to understand that we also make images for that child when [he or she] becomes an adult. When they look back at those images and see themselves as they were, they are looking for their parents when they were

young. Such is the power and value of portraiture."

On a very basic level, the portrait is a means to remembering—it is a memory, and a strong one at that. "This is how sister Dorothy looked when she was seven—she still has that same goofy grin almost a half century later!" This function of the portrait, while on the surface mundane, is no less important than the view of the portrait as psychological profile, historical tapestry, or any other of its popular definitions.

In the early years of photographic portraiture, posing was an absolute necessity. With extremely slow films, equally slow lenses, and a lack of artificial light sources, time dictated long exposures. The headrest functioned as the "immobilizer," giving photographers the ability to record their subjects at long exposure times—often several minutes long—without subject movement. As Don Blair notes, the poses were stiff and unnatural and the expressions ranged from pained to grim.

All that has changed by virtue of vastly improved technology that has allowed photographers to work freely and naturally and to record spontaneity in their portraits. But also gone is the almost rigid framework of poses that developed over the centuries. The way photographers reveal the human form has given way to a love of naturalness—unposed, softly lit images that are often lacking that delicate expertise that inspires the viewer's imagination.

The great portrait photographers of today have not completely lost sight of the posing rules that existed, but have chosen to incorporate them into a freer framework of informality. That is to say, they haven't lost the understanding of fundamental posing, but instead have chosen to interpret those rules less rigidly.

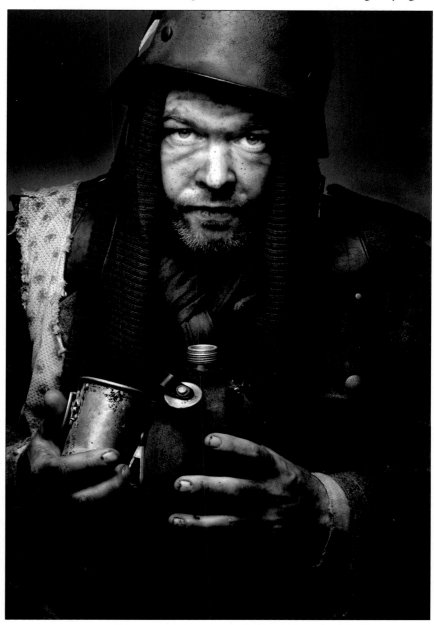

▲ Portraiture has always had the ability to transcend the literal, becoming works of art. Such is the case with *Deiter—Russia—1943*, created by David Williams. The subject represents a once-proud World War II German Wermacht soldier after the collapse of the Russian campaign. His clothing indicates he's now living "very rough." The items in his hands suggest a return to the basic necessity of staying alive.

◄ Today's finest portrait photographers are, many times, also today's finest wedding photographers; the two disciplines go hand-in-hand. Here, Yervant Zanazanian has created a timeless wedding pose by eliminating all but the hand and smile of the bride. The sheer beauty found in the curl of the wrist and fingers holding the perfume bottle created an elegant, unforgettable image.

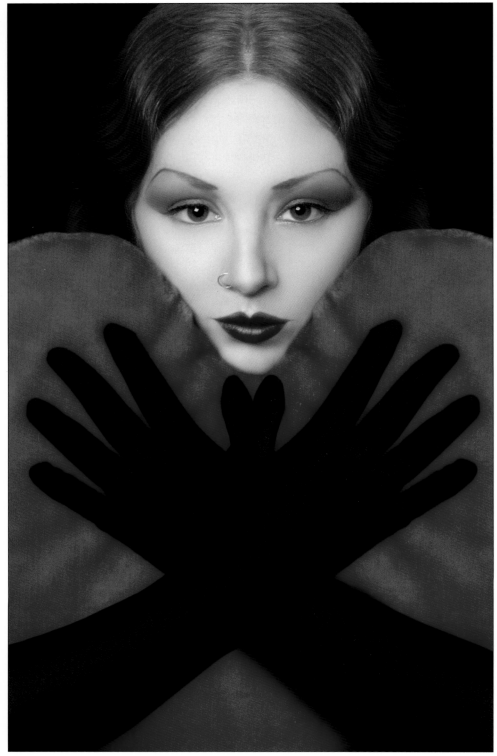

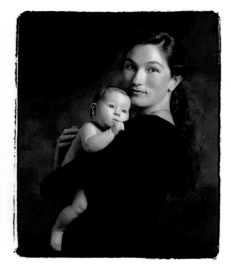

Universally renowned portrait photographer Tim Kelly is someone who knows the intricacies of posing inside and out but chooses to set a different standard for fine portraiture; he will break the rules almost recklessly to uncover personality and mood—the heart of his subjects. He looks for that fleeting moment when you may glimpse the subject "in a semi-posed moment of self-revelation." Kelly does not usually warn his clients that he is ready to begin a session. He says, "I don't believe in faking the spontaneity of the subject's expression. Every session promises something unique and unstructured." Kelly calls this style "the captured moment," not too different from the viewpoint of the wedding photojournalist, for whom spontaneity and capturing the emotion of the moment are more important than the elegant perfect pose of the formal bridal portrait. Kelly demands more than a likeness from his portraits. He

comments, "An artistic portrait should command attention, make an artistic statement, or trigger an emotional response from the viewer." He adds, "A fine art portrait transcends time. It goes far beyond the utilitarian uses of the subjects, the people portrayed."

Decorated Australian wedding and portrait photographer Martin Schembri uses the *Mona Lisa* as his benchmark of portraiture, saying that "it is the essence of the person captured in a single expression." While a Schembri portrait can be

► This is not a production still of *Les Miserables*, it is a real portrait of a real person made by Marcus Bell. Here's the story of *Irishman*, in Marcus Bell's own words. "This image is a very memorable one for me. My wife and I were exploring the bottom eastern tip of Ireland near Ballinskellings. We drove for miles up a dirt road and came across this artist's village. It was very remote—deserted. We passed a little farmhouse and a man jumped out and waved me down. We pulled up and he started talking. We could hardly understand him (his accent was so strong). He was the most amazing man. Finally, we worked out that he wanted to give us his dog so we could look after it—he could no longer afford to keep his dog and was looking for someone caring to look after it. It was very sad, and we knew we couldn't take it because we were traveling. After a long conversation we finally left and headed down the road, I got only fifty meters when it hit me. Why don't I ask to photograph him? I don't know why I didn't think of it earlier. I guess it was the emotion of his story. I stopped the car, grabbed my camera, and ran back, asking if I could take his picture. He was reluctant, but as we kept talking I started to fire a few shots off and he started to relax then he slowly forgot about the camera and became just himself. Then I could see tears well up in his eyes and I took the shot *Irishman*. I thought I had taken it too far and shouldn't have photographed him. I said to him, 'I'm sorry. I shouldn't have done that.' He turned to me and said, 'It's not the camera; no one has ever taken the time to listen.' I was the first in years to simply stop, listen, and care. At the time, I was a young man just at the beginning of my journey with my best friend, my wife. Because we were traveling, I was unable to process the film I had shot until six weeks later. As soon I saw the contact sheet the image jumped out at me like none before. That day I knew my journey as a photographer was just starting."

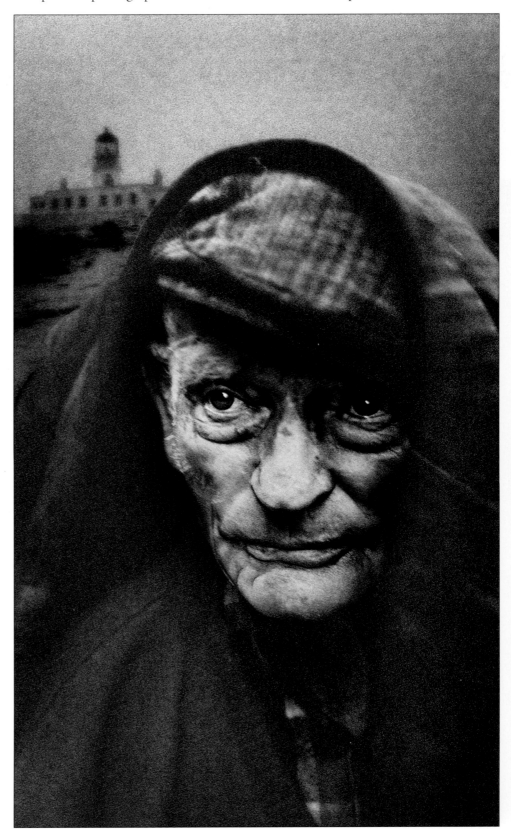

made classically or in a very informal style, he demands that the posing of all of his portraits be comfortable and natural (to the viewer) and that they not appear contrived. He offers this advice about making each portrait unique: "Ensure that your portraits are as individual as each person you photograph, and never treat the exercise as one in which the technicalities rule."

Fine portraiture is often seen as a storytelling device used to tell a tale of the human condition, using the portrait subject as the vehicle for a higher plane of communication. Even at its most basic level, the portrait is an ingenious storytelling device—whether it be the future of endless possibilities seen in a schoolgirl's hopeful gaze or the stoic grit of a soldier pictured in full military dress. Portraits invite the imagination to probe and find deeper understanding and meaning.

David Williams, who is as articulate about the art of portraiture as he is a gifted portrait artist, recently summed up what great portraiture is all about. He said, "Our photography is about life. Is there a life force in the image?" The life force is the overpowering effect of portraiture that keeps "the affected" coming back for more. In great portraiture, we rediscover what it is that makes us feel alive and great, both individually and collectively. We also rediscover what it is that makes us all human and vulnerable and what it is that makes us laugh and cry and feel connected to one another.

The great portrait has a tradition of classical elegance built on a system of posing, lighting, and composition that goes back to the

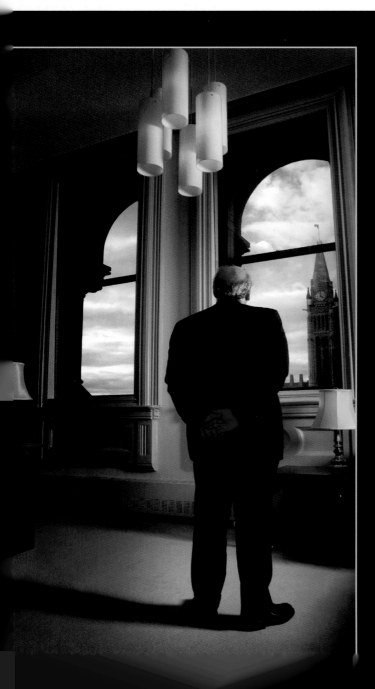

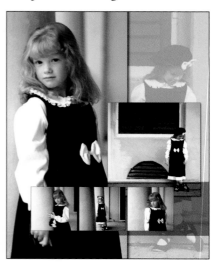

▲ In a digitally composed panel of portraits, Martin Schembri reveals multiple sides of this beautiful little girl's personality.

◄ Anthony Cava created this powerful portrait of a high-ranking public servant in the Canadian government. Anthony was commissioned to create the man's portrait. "I had ten minutes before his next appointment. After we were done, he moved to the window and I fired off six shots. This was the best one." The image was made by available light with flash-fill and a Nikon D1X.

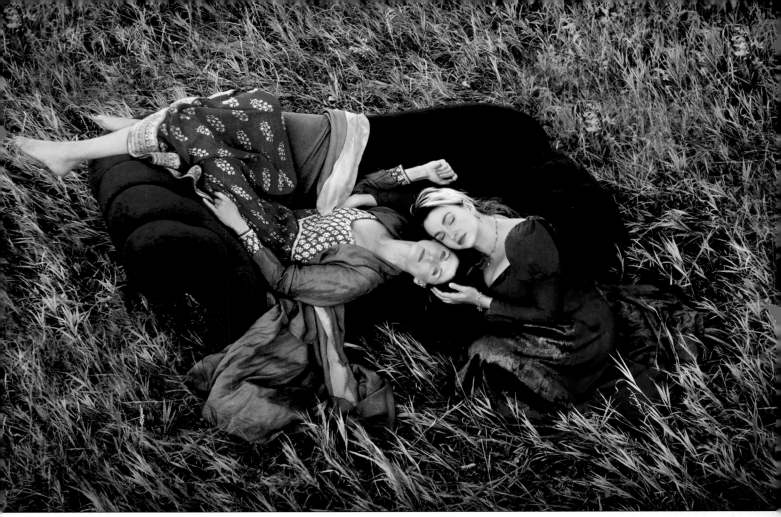

▲ Deanna Urs created this arresting pose of a mother and daughter in a field of Indian paintbrush grasses. Deanna created this pose to show the bond between mother and daughter. The time of day was early evening; the point of view was from a 10-foot stepladder. She used a 28–70mm f/2.8 lens almost wide open (being elevated on the ladder flattened the field of focus, making a smaller aperture unnecessary). The fabrics were chosen for their richness and color saturation. Deanna feels that the more one knows about the reflective qualities of various fabrics, the more effective a photographer one will be. This light was the light of late afternoon, and yes, she had the burgundy sofa moved to the location for the portrait. The title of the image is *My Mother, My Daughter.*

cave paintings of precivilization—the earliest rendered portraits. The greatest examples of fine portraiture exhibit a sense of simplicity of design and an orderliness that has come from generations of perfecting the craft. The most appealing aspect of portraiture, whether it is contemporary or from the 18th century, is that it can be all of these things or none of them. It can be an homage or a completely new form or approach to capturing the human spirit, but what makes portraiture compelling for the ages is

that we never cease redefining how we see ourselves. The portrait will always be a relevant contemporary art form. Like Narcissus, we never grow tired of seeing our own endless reflection.

I wish to thank all of the incredible photographers who helped me in the preparation of this book. Some of them, like Bill McIntosh, Don Blair, and Monty Zucker, have been working portrait photographers for close to sixty years. Others, like David Williams and Martin Schembri, are

relatively new kids on the block, and yet have managed to make significant contributions to a genre that includes the likes of Michelangelo and DaVinci.

THE PHOTOGRAPHERS

Becker—Becker, who goes by only his last name, is a gregarious, likeable wedding photojournalist who operates a successful studio in Mission Viejo, California. He has been a featured speaker at WPPI and has also competed and done well in international print competition.

David Beckstead—David Beckstead has lived in a small town in Arizona for over twenty years. With help from Internet forums, digital cameras, seminars, WPPI (Wedding and Portrait Photographers International), Pictage, and his artistic background, his passion has grown into a national and international wedding photography business. He refers to his style of wedding photography as Artistic Photojournalism.

Vladimir Bekker—Vladimir Bekker, owner of Concord Photography in Toronto, Canada, specializes in weddings and environmental portraits. An immigrant from the Ukraine, Vladimir took up photography when he was a boy. He is a graduate of Lvov Polytechnical University with a master's degree in architecture, which explains why many of his wedding images include architectural details. His studio photographs over a hundred weddings a year. He has won numerous international awards for his prints and albums.

Marcus Bell—Marcus Bell's creative vision, fluid natural style, and sensitivity have made him one of Australia's most revered photographers. It's this talent combined with his natural ability to make people feel at ease in front of the lens that attracts so many of his clients. His work has been published in numerous magazines in Australia and overseas including *Black White, Capture, Portfolio Bride*, and countless other bridal magazines.

David Bentley—David Bentley owns and operates Bentley Studio, Ltd. in Frontenac, Missouri. With a background in engineering, he calls upon a systematic and creative approach to each of his assignments. His thirty years of experience and numerous awards speak to the success of the system.

Clay Blackmore—Clay Blackmore is an award-winning photographer from Rockville, Maryland. He has been honored by the PPA (Professional Photographers of America) and WPPI and is a featured presenter on the lecture circuit around the United States. He started out as Monte Zucker's assistant.

Don Blair (Master of Photography, Cr., CPP)—World-famous photographer and teacher Don Blair, also known as "Big Daddy," is the author of numerous books and videos on lighting and posing, including *Portrait Photography: The Art of Seeing Light* (Amherst Media, 2004). Don has been awarded virtually every award in professional photography and is a member of the Photography Hall of Fame.

Joe Buissink—Joe Buissink is an internationally recognized wedding photographer from Beverly Hills, California. Almost every potential bride who picks up a bridal magazine will have seen his photos. He has done many celebrity weddings, including Jennifer Lopez's 2002 wedding, and is a Grand Award winner in WPPI print competition. Joe speaks regularly to national and international audiences.

Bambi Cantrell—Bambi is a highly decorated photographer from the San Francisco Bay area. She is well known for her creative photojournalistic style and is the recent coauthor of a best-selling book on wedding photography, entitled *The Art of Wedding Photography* (Amphoto, 2002). Bambi is a highly sought-after speaker at national photographic conventions and schools.

Larry Capdeville (M. Photog.)—Larry Capdeville has been a professional photographer since 1973 and has received numerous awards, including the Fuji Masterpiece Award and several PPA Loan Collection Prints. He has been named as one of Florida's top-ten photographers for the last ten years. He is a member of PPA and WPPI and has been recognized by both organizations.

Anthony Cava (B.A., MPA, APPO)—Born and raised in Ottawa, Ontario, Canada, Anthony Cava owns and operates Photolux Studio with his brother, Frank. Frank and Anthony's parents originally founded Photolux as a wedding and portrait studio thirty years ago. Anthony joined WPPI and the Professional Photographers of Canada ten years ago. At thirty-three, he was the youngest Master of Photographic Arts (MPA) in Canada. He won WPPI's first Grand Award with the first print that he ever entered in competition.

Michele Celentano—Michele Celentano graduated the Germain School of Photography in 1991. She spent the next four years assisting and photographing weddings for other studios. In 1995 she started her own business photographing only weddings. In 1997 she received her certification from the PPA. She has since become a nationally recognized speaker on the art of wedding photography and has recently relocated her business from New York to Arizona.

Mike Colón—Mike Colón is a celebrated wedding photojournalist from the San Diego area. Colón's work reveals his love for people and his passion for celebrating life. His natural and fun approach frees his subjects to be themselves, revealing their true personality and emotion. His images combine inner beauty, joy, life, and love frozen in time forever. He has spoken before national audiences on the art of wedding photography.

Jerry D—Jerry D owns and operates Enchanted Memories, a successful portrait and wedding studio located in Upland, California. Jerry has had several careers in his lifetime, from licensed cosmetologist to black-belt martial arts instructor. Jerry's work has been highly honored by WPPI, and he has achieved many national awards since joining the organization.

Stephen Dantzig (Psy.D)—Dr. Stephen Dantzig owns and operates a small commercial studio just north of Los Angeles. His work ranges from commercial fashion to products and interiors to executive portraits.

Terry Deglau—Terry Deglau has been a professional portrait photographer for over forty years. He is the former manager of trade relations at Eastman Kodak Company and currently operates his own business in Pittsburgh, Pennsylvania. Terry is a Rochester Institute of Technology graduate with a degree in Photographic Science and a marketing degree from the University of Pittsburgh. Terry has lectured extensively throughout the US and the world.

Fuzzy Duenkel (M.Photog., Cr., CPP)—Fuzzy and Shirley Duenkel of West Bend, Wisconsin operate a thriving portrait studio concentrating primarily on seniors. Fuzzy has been highly decorated by the PPA, both nationally and in Wisconsin, having won nine Photographer of the Year, Best of Show, and Photographers' Choice awards at Wisconsin PPA's senior-folio competitions. Fuzzy has had twelve prints selected for the National Traveling Loan Collection, two for Disney's Epcot Center, one for Photokina in Germany, and one for the International Photography Hall of Fame and Museum in Oklahoma. Fuzzy's custom senior portraits, created in and around his subjects' homes, allow and encourage an endless variety.

William L. Duncan (M. Photog. CPP, APM, AOPM, AEPA)—Bill Duncan was one of the first members of WPPI with three levels of achievement. He has been a consistent winner in print competitions from all organizations, and he is known around country for his unique images. He conducts seminars entitled "Artistry in the Language of Light."

Deborah Lynn Ferro—A professional photographer since 1996, Deborah calls upon her background as a watercolor artist. She has studied with master photographers all over the world, including Michael Taylor, Helen Yancy, Bobbi Lane, Monte Zucker, and Tim Kelly. In addition to being a fine photographer, she is also an accomplished digital artist. With her husband, Rick Ferro, she is the coauthor of *Wedding Photography with Adobe Photoshop* (Amherst Media, 2003).

Frank A. Frost, Jr. (PPA-Certified, M. Photog., Cr., APM, AOPA. AEPA. AHPA)—Frank Frost has been creating his classic portraiture in Albuquerque, New Mexico for over eighteen years. Believing that "success is in the details," Frank pursues both the artistry and business of photography with remarkable results, earning him numerous awards from WPPI and PPA along the way. His photographic ability stems from an instinctive flair for posing, composition, and lighting.

Jennifer George Walker—Jennifer George Walker runs her studio out of her home in the San Diego, California community of Del Mar. The affluent neighborhood is close to the beach and a variety of beautiful shooting locations, and is lush with prospective clients. In 2001, she was named the California Photographer of the Year and won the People's Choice Award 2001 at the Professional Photographers of California Convention. In 2003, Jennifer was the "premiere" category Grand Award winner. You can view more of Walker's images at www.jwalkerphotography.com.

Jerry Ghionis—Jerry Ghionis of XSiGHT Photography and Video started his professional career in 1994 and has quickly established himself as one of Australia's leading photographers. His versatility extends to the wedding, portrait, fashion, and corporate fields. In 1999, the Australian Institute of Professional Photography (AIPP) recognized Jerry's efforts, honoring him as the best new talent in Victoria. In 2002, Jerry won the AIPP Victorian Wedding Album of the Year, and in 2003 he won Wedding Album of the Year—while also taking the Grand Award in the album competition at WPPI.

Ann Hamilton—Ann Hamilton began her professional career as a journalist writing lifestyle stories for an east-coast newspaper. Now, as a photographer documenting weddings, Ann combines her love of photography with a journalistic sense and artistic flair. Her images capture the true story of a wedding—from the moment a bride slips into her dress, to the couple's first kiss and last dance, and all the joy in between. Ann's work was has been featured in *Wedding Bells* and *The Knot* magazines. She also won two honorable mentions at the WPPI International print competition. She and her husband, Austin, with their pug, Bogie, reside in San Francisco, California.

Elizabeth Homan—Elizabeth Homan owns and operates Artistic Images and is assisted by her husband, Trey, and her parents, Penny and Sterling. They opened their country-styled studio in 1996. Elizabeth holds a BA from Texas Christian University and was decorated as the youngest Master Photographer in Texas in 1998. She also holds ten Fujifilm Masterpiece Awards, and was awarded Best Wedding Album in the Southwest Region for six years, receiving two perfect scores of 100.

Giorgio Karayiannis—Giorgio Karayiannis is one of those rare photographers who specializes in editorial, fashion, advertising, commercial, *and* portrait photography—and is successful in each discipline. He has been a technical photographic adviser for the Ilford

Imaging Group International. He is recognized for his very strong ability to produce graphically intense images. He passionately loves his work and has an unsurpassed enthusiasm for any assignment. His commitment to excellence has been recognized, and he was recently named by the Australian Institute of Australian Photographers as their Editorial Photographer of the Year and by AIPP as their Victorian Portrait Photographer of the Year. He has also been an award winner at WPPI.

Tim Kelly—Tim Kelly has won almost every available photography award. He not only holds the degrees of Master of Photography and Photographic Craftsman, but he has also amassed numerous awards—the PPA Loan Collection, Kodak Gallery, Gallery Elite, and Epcot Awards, to name a few. Kelly, a long time member of Kodak's Pro Team, has been under the wing of their sponsorship since 1988. In 2001, Kelly was awarded a fellowship in the American Society of Photographers (ASP) and was named to the prestigious Cameracraftsmen of America. Most recently, the Photography Hall of Fame in Oklahoma City announced that it will display a Kelly portrait and an album of images in their permanent collection. Kelly's studio and gallery in the North Orlando suburb of Lake Mary, Florida, is the epitome of a high-end creative environment.

Brian King—Brian King of Cubberly Studios in Ohio began accumulating awards for his artwork in elementary school. He attended the Ohio Institute of Photography, graduating in 1994, and went straight to work at Cubberly Studios in Ohio. Earning both his Certified Professional Photographer and Master of Photography degrees from PPA, he is a member of PPO-PPA Senior Photographers International and ASP.

Kevin Kubota—Kevin Kubota formed Kubota Photo-Design in 1990 as a solution to stifled personal creativity. The studio shoots a mixture of wedding, portrait, and commercial photography. Kubota Photo-Design was one of the early pioneers in pure digital wedding photography in the late 1990s. Drawing on this experience, Kevin lectures and trains other photographers to make a successful transition from film to digital.

Robert Lino, M. Photo., Cr., PPA Cert., APM, AOPM, AEPA, FDPE, FSA—Robert Lino of Miami, Florida specializes in fine portraiture and social events. His style is formal and elegant, displaying an exceptional ability to capture feeling and emotion in every image. Lino is a highly decorated photographer in national print competitions and is a regular on the workshop and seminar circuit.

Rita Loy—With her husband Doug, Rita Loy is the co-owner of Designing Portrait Images, a studio in Spartanburg, South Carolina. Rita is a seventeen-time recipient of Kodak's Gallery Award of Photographic Excellence, an eight-time winner of the Fuji Masterpiece Award and she has been voted South Carolina's Photographer of the Year a record eight times. She has won awards, both national and regional, too numerous to mention. Rita is also a member of Kodak's prestigious Pro Team.

Tammy Loya—Tammy Loya is an award-winning children's portrait specialist from Ballston-Spa, NY. In her first WPPI Awards of Excellence print competition, she won a first and second place in the "children" category. All her other entries received honorable mentions. Her studio is a converted barn, where her clients preview their images in a space known as the Jailhouse Rock Theater.

William S. McIntosh (M. Photog., Cr., F-ASP)—Bill McIntosh photographs executives and their families all over the US and travels to England frequently on special assignments. He has lectured all over the world. His popular book, *Location Portraiture: The Story Behind the Art*, is sold in bookstores and other outlets around the country. He is the author of *Classic Portrait Photography: Techniques and Images from a Master Photographer* (Amherst Media, 2004).

Mercury Megaloudis—Mercury Megaloudis is an award-winning Australian photographer and owner of Megagraphics Photography in Strathmore, Victoria, Australia. The AIPP awarded him the Master of Photography degree in 1999, and he has won additional awards all over Australia. He has recently begun entering and winning print competitions in the US.

Dennis Orchard—Dennis Orchard is an award-winning photographer from Great Britain. He has been a speaker and an award winner at WPPI conventions and print competitions. He is a member of the British Guild of Portrait and Wedding Photographers.

Larry Peters—Larry Peters is one of the most successful and award-winning senior and teen photographers in the nation. He operates three highly successful studios in Ohio and is the author of two books, *Senior Portraits* (Studio Press, 1987) and *Contemporary Photography* (Marathon Press, 1995). His web site is loaded with good information about photographing seniors: www.petersphotography.com.

Norman Phillips (AOPA)—Norman Phillips has been awarded the WPPI Accolade of Outstanding Photographic Achievement (AOPA). He is also a registered Master Photographer with Britain's Master Photographers Association, a Fellow of the Society of Wedding and Portrait Photographers, and a Technical Fellow of the Chicagoland Professional Photographers Association. He is a frequent contributor to photographic publications, a print judge, and a guest speaker at seminars and workshops across the country.

Joe Photo—Joe Paulcivic III is a second-generation photographer who goes by the name of Joe Photo, his license plate in high school. He is an award-winning wedding photojournalist from San Juan Capistrano, California. Joe has won numerous first place awards in WPPI's print competition, and his distinctive style of wedding photography reflects the trends seen in today's fashion and bridal magazines. The images are spontaneous and natural rather than precisely posed.

Stephen Pugh—Stephen Pugh is a wedding photographer from Great Britain. He is a competing member of both WPPI and the British Guild and has won numerous awards in international print competitions.

Fran Reisner—Fran Reisner is a Brooks Institute graduate and has twice been named Dallas Photographer of the Year. She is also a past president of the Dallas Professional Photographers Association. Fran runs a highly successful low-volume portrait and wedding business from the studio she designed and built on her residential property. She

has won numerous state, regional, and national awards for her photography.

Martin Schembri (M. Photog. AIPP)—Martin Schembri has been winning national awards in his native Australia for twenty years. He has achieved a Double Master of Photography with the AIPP. He is an internationally recognized portrait, wedding, and commercial photographer and has conducted seminars on his unique style of creative photography all over the world.

Kenneth Sklute—Beginning his wedding photography career as a teenager, Kenneth quickly advanced to shooting an average of 150 weddings a year. He purchased his first studio in 1984 and received his Masters degree from PPA in 1986. Kenneth is much decorated, having been named Long Island Wedding Photographer of the Year fourteen times, PPPA Photographer of the Year, and APPA Wedding Photographer of the Year. He has also won numerous Fuji Masterpiece Awards and Kodak Gallery Awards.

Jeff Smith—Jeff Smith is an award-winning senior photographer from Fresno, California. He owns and operates two studios in Central California. He is well recognized as a speaker on lighting and senior photography and is the author of *Corrective Lighting and Posing for Portrait Photographers* (Amherst Media, 2001), *Senior Contracts* (self-published), *Outdoor and Location Portrait Photography* (Amherst Media, 2002), *Success in Portrait Photography* (Amherst Media, 2003), and *Professional Digital Portrait Photography* (Amherst Media, 2003). He can be reached at his web site, www.jeff-smithphoto.com.

Michael Taylor—Michael Taylor is the owner of Taylor Fine Portraiture in Pasadena, California. He is highly decorated by the PPA and, in fact, serves on that organization's board. Taylor is a big believer in community involvement and for twenty years has been an active member of the Junior League, an association that has led both to satisfaction and recognition in the affluent community of Pasadena.

Brook and Alisha Todd—Brook and Alisha Todd are young photographers from Aptos, California (near San Francisco). They have become known for their elite brand of wedding photo-journalism. Together, Alisha and Brook photograph the wedding with "one passion and two visions." The Todds are members of both PPA and WPPI and have been honored in WPPI's print competition.

Deanna Urs—Deanna Urs lives in Parker, Colorado with her husband and children. She has turned her love and passion for the camera into a portrait business that has created a national and international following. Deanna uses natural light and chooses to have subtle expressions from her clients, as she feels these lead to more soulful portraits that will be viewed as art and as an heirloom. She works in her client's environment to add a personal touch her portraits. Visit Deanna's web site at www.deannaursphotography.com/.

David Anthony Williams (M.Photog. FRPS, ALPE)—David Anthony Williams owns and operates a wedding studio in Ashburton, Victoria, Australia. In 1992, he achieved the rare distinction of Associateship and Fellowship of the Royal Photographic Society of Great Britain on the same day. Through the annual Australian Professional Photography Awards system, Williams achieved the level of Master of Photography with Gold Bar—the equivalent of a double master. In 2000, he was awarded the Accolade of Outstanding Photographic Achievement from WPPI, and has been a Grand Award winner at their annual conventions in 1997 and 2000 and 2002.

James C. Williams—James Williams and his wife Cathy own and operate Williams Photography in Warren, Ohio. James is PPA Certified and also has been Certified through the Professional Photographers of Ohio. In 2001, Williams was inducted into the Professional Photographers Society of Ohio; membership is by invitation only. Currently Williams is working on his Craftsman and Masters Degrees.

Yervant Zanazanian (M. Photog. AIPP, F.AIPP)—Yervant was born in Ethiopia, then lived and studied in Venice, Italy prior to settling in Australia twenty-five years ago where he continued his education at the Photography Studies College in Melbourne. Yervant's passion for photography and the darkroom were encouraged at a very young age when he worked in his father's photography business after school and during school holidays. His father was photographer to the Emperor Hailé Selassé of Ethiopia. Yervant owns one of the most prestigious photography studios in Australia and services clients both nationally and internationally. His awards are too numerous to mention, but he has been Australia's Wedding Photographer of the Year three of the past four years.

Monte Zucker—When it comes to perfection in posing and lighting, timeless imagery, and contemporary yet classical photographs, Monte Zucker is world-famous. He's been bestowed every major honor the photographic profession can offer, including WPPI's Lifetime Achievement Award. In 2002, Monte received the International Photography Council's International Portrait Photographer of the Year Award, presented at the United Nations. In his endeavor to educate photographers at the highest level, Monte, with partner Gary Bernstein, has created Zuga.net, an information-based web site for photographers.

CHAPTER ONE
POSING
BASICS

The rules regarding posing were established over the centuries to provide a means of appealingly rendering the three-dimensional human form in a two-dimensional medium. Certainly, highlight and shadow are the brushes for revealing form, but of equal importance is the positioning of the human form in front of the camera and within the borders of the picture's rectangular or square frame.

In any discussion of subject posing, the two most important elements to keep in mind are that the pose appear natural (i.e., that the subject does not *look* posed), and that the person's features be undistorted. If the pose is natural and the features are rendered normally, in proper perspective, then you will have achieved a major goal, and the portrait will generally be considered aesthetically pleasing to both the photographer and the subject. To be certain, there is much more that goes into a great portrait than adequate posing, but without these elements, the more artistic elements would not be appreciated or even noticed.

While every rule of posing could not possibly be followed in

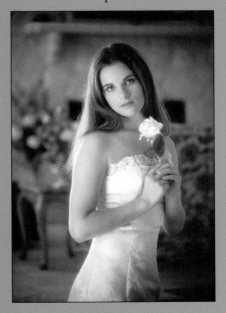

◄ Fuzzy Duenkel specializes in senior and teen photography. Here, the girl's body is turned at about a 45-degree angle to the camera; her head is turned back toward the camera at a lesser angle. The head is tilted toward the near shoulder in a decidedly "feminine" pose. The image was made with window light and one of Fuzzy's homemade reflectors.

every portrait, these rules do exist for a purpose. In short, they provide a framework for achieving the aforementioned goals, portraying the human form naturally, flatteringly, and without distortion.

● BREAKING THE RULES
While the phrase "rules are made to be broken" is refreshing in most instances, fine portraitists know *which* rules can be broken without distorting the human form. For instance, what photographer has not fallen in love with the viewpoint and effects of the wide-angle lens? The foreground spreads out before you in panoramic fashion, the horizon line bows, the sky naturally vignettes at the corners of the frame. Yet, the wide-angle lens, when used in portraiture, creates a number of difficulties. If the subject is not dead-center in the frame, for example, either the head or the feet of the subject will distort. And if used close-up in a head-and-shoulders portrait, the nose will project toward the camera like a missile, while the eyes and forehead will recede with unflatter-

ing abruptness. Still, in the hands of an experienced professional, the wide-angle lens can be an amazingly efficient portrait lens, revealing both the character of the subject and the intimacy of his or her surroundings.

● THE BASICS

Head and Shoulders. The first rule of good portraiture is that the subject's shoulders should be turned at an angle to the camera. To have the shoulders facing the camera straight on makes the person look wider and stockier than normal. Although this pose is used frequently in the world of fashion (where models are thin and unusually well proportioned), you will not often see it when "regular people" are photographed.

Whether the subject is seated or standing, another rule concerns the line of the shoulders. One shoulder should be noticeably higher than the other, which is to say that the line of the shoulders should not be parallel to the ground.

Start with the Feet. In practical terms, to accomplish this correct positioning of the shoulders in a portrait where the subject is standing, you should start with the feet. The basic rule is that no one should have both feet together. Instead, one foot should be brought forward. This causes the shoulders to turn at a slight angle to the camera. The subject should also place his or her weight on the back leg—as this causes the forward knee to bend and the rear shoulder to dip lower than the forward one.

In a seated portrait, simply having the subject lean forward from the waist will create a sloping line to the shoulders, provided that the person is at an angle to the camera.

Simply positioning the body in this way creates the first and basic dynamic lines within the composition, since the resulting lines in the body will now be diagonal instead of vertical or horizontal.

Head Tilt. With the shoulders turned at an angle to the camera, the head is then turned or tilted, usually at a different angle than the shoulders. By doing this, you slant the natural line of the person's eyes. When the face is not tilted, the line of the eyes is straight and parallel to the bottom edge of the photograph, leading to a symmetrical, static image. By tilting the person's face right or left, the implied line becomes diagonal, making the pose more dynamic and interesting to the viewer.

These posing guidelines are in effect, regardless of whether the photo is a close-up, head-and-shoulders, or full-length portrait. As with most posing suggestions,

▼ With children and very slender women it is not necessary to tilt the body to the camera. They are either thin enough or small enough so that they don't take on mass in front of the camera. This is an elegant fashion portrait by Martin Schembri, who used a single light source and Photoshop effects to produce this minimalist image.

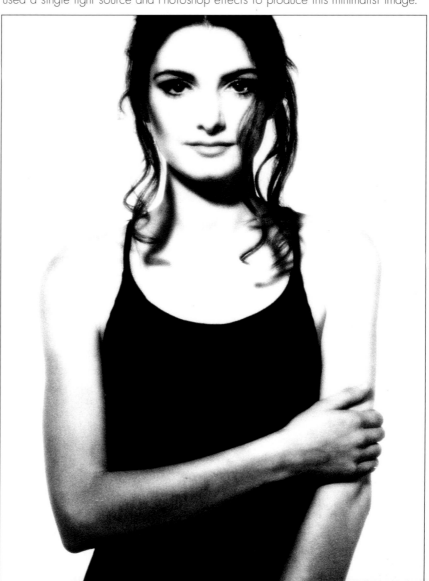

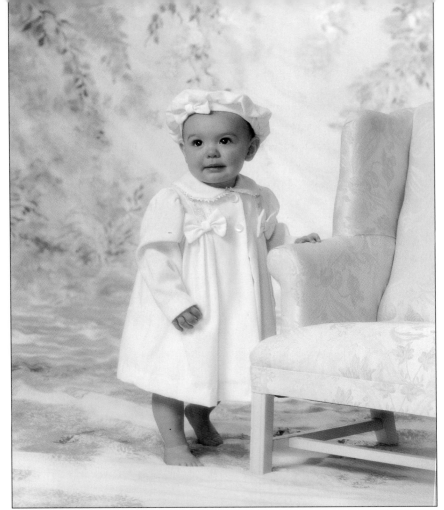

► Rita Loy loves photographing kids—and here you can see that this little one's balance is not so good, so she gave her an undersized white chair to hold on to and a soft, padded floor (beneath the painted backdrop). Rita arranged the props so that the baby would be properly turned for good posing and facing the soft light.

► (BOTTOM) Joe Photo used natural light to create this portrait of a bride. Note the triangle base of her elbows as she leans on the railing—it's always a firm foundation for a portrait.

keep in mind that a more natural look is achieved when the tilt of the person's head is slight and not exaggerated.

With men, the head is frequently tilted toward the low shoulder (farthest from the camera lens), and the head and body are turned in the same direction—often toward the light source, with the body at a 45-degree angle to the camera. In a seated masculine portrait, men are often pictured leaning in toward the camera, considered an aggressive pose.

With women, the head is usually turned and tilted toward the high shoulder (the one nearest the camera lens). The body is leaned forward at the waist and is then leaned slightly in the opposite direction from the way the face is turned. For example, if the subject is looking to her left shoulder, the body leans to the right. In the feminine pose, the body often faces away from the light source, but the face is turned toward the light.

While this is something of a cliché technique for posing, like most clichés, it exists for a reason. The masculine tilt of the head provides the impression of strength—a

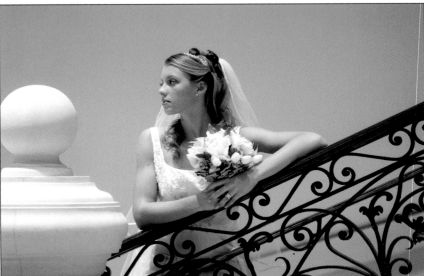

traditional male characteristic; while the head tilted toward the near shoulder, the feminine pose, creates the impression of mystery and vulnerability—characteristically female traits. Whether to tilt the subject's head toward the near

shoulder or the far shoulder is a somewhat controversial issue among portrait photographers. These "rules" are frequently disregarded because individual differences and lighting will determine whether the person is better por-

trayed as strong or vulnerable, but the strategy is mentioned here so that you can decide for yourself.

Body at an Angle to the Camera. As with the planes of the face, turning the body plane so that it is at an angle to the camera will produce a more dynamic effect and will enhance the various curves and planes of the body. The only exception is when you want to emphasize the mass of the subject, such as with an athlete, or when the person is very petite or thin—a child or a model, for example. One of the basic requirements of a good working model is that she be thin so that, if need be, she can be photographed head-on without looking larger than average.

Turn Away from the Main Light. Turning the body away from the main light will help to maximize body definition and enhance the detail in clothing, like the subtle beadwork of a bride's wedding dress. If you face the subject's body plane toward the light source, you risk "washing-out" or flattening-out important detail in both the form of the body and the texture of the clothing.

▶ This is the head-on view, which is not normally seen in portraiture, but makes frequent appearances in the world of fashion. Monte Zucker created this portrait using the direct, straight-on view and a large diffused light plus a reflector to flood the face with soft, wraparound light. In these instances, makeup, not lighting, does the contouring. You can see in her eyes the twin catchlights of the diffused main light source and the reflector placed over and under the lens. Monte's use of the hands to form an appealing frame for the face is reminiscent of a flower shape.

Posture. Good posture is essential to an effectively rendered body plane. You must be conscious of the subject slouching and be prepared to improve the pose by coaching or placing a hand on the small of the subject's back, which will automatically cause the spine to stretch and elongate.

Arms and the Triangle Base. The triangle is one of the most pleasing and dynamic forms in all of photography. Because the triangle is a series of three lines, two of which are diagonal, it has the result of providing direction and visual movement in a portrait. Creating triangles and exploiting natural triangles in posing is one of the basic skills of good composition.

To create a triangular base for the composition, the subject's arms

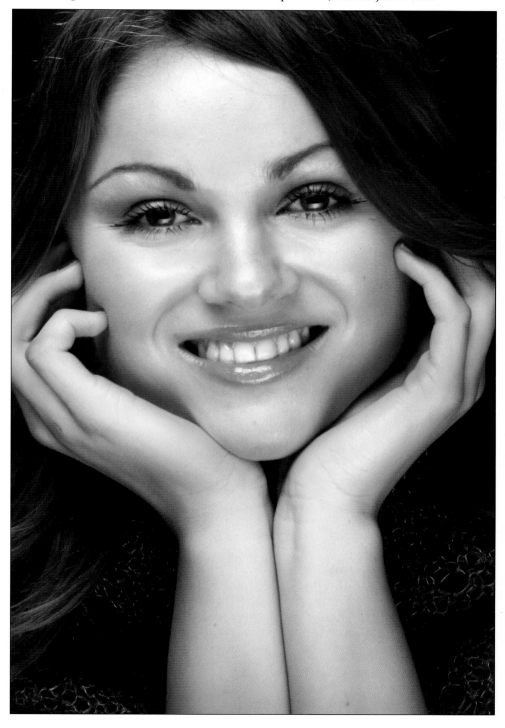

(regardless of how much of the subject is showing in the final portrait) should not be allowed to fall to their sides, but should project outward to provide gently sloping lines. This is commonly achieved by asking the subjects to separate their arms from their torso, creating a bend in the elbows. In a seated portrait, what normally happens is that the subject will move his or her joined hands closer to the waist, thus producing slightly projecting elbows.

In a standing portrait, you can have men place their hands in their pants pockets to produce the triangular base; women can rest one or both hands on the hips. There should also be a space between their upper arms and torsos. This triangular base in the composition attracts the viewer's eye upward, toward the subject's face.

Another way to accomplish the triangular base is with a posing table on which the far elbow can be rested. This provides the sloping line of the shoulders and the triangular base so vital to good composition. The posing table is usually black and nearly invisible in the final portrait; in fact, it is often cropped from the composition. More will be said about the triangle form in chapter 4.

● REFINEMENTS:
HEAD POSITIONS
As important as the position of the subject's body is the position of the subject's head in relation to the body. As outlined above, the head should be at a different angle than the shoulders, which should also be at an angle to the camera. This creates a series of dynamic lines within the portrait and defines the

basic nature of the pose—masculine or feminine. In both poses, the face is directed at about 45 degrees to the direction of the body. The shoulders are sloped, not parallel to the ground, and the head is tipped toward one shoulder or the other.

The Seven-Eighths View. There are three basic head positions in portraiture. The seven-eighths view is achieved when the subject is looking slightly away from the camera. You will see a little more of one side of the face than the other when looking through the viewfinder, and you will still see the subject's far ear.

The Three-Quarter View. In the three-quarter view, the far ear is hidden from the camera, and more of one side of the face is visible. With this type of pose, the far eye will appear smaller because it is farther away from the camera. It is

▲ **(LEFT)** The three-quarter facial view is the most common head position because it allows the photographer to show all of the curved planes of the face. Deborah Lynn Ferro created this beautiful image by carefully lighting her subject with soft, wraparound light. The shadow side of the face (closest to the camera) shows gentle gradation, which in turn shows roundness and form. Also note how delicately the hands are posed, producing a curved horizontal base to the composition.
▲ **(RIGHT)** Fuzzy Duenkel created this charming portrait with a three-quarter facial view. While this view is getting close to a profile, the photographer made sure you could see both eyes clearly in the pose. Note the very shallow depth of field that isolates the girl against a muted green foreground and background.

► Fuzzy Duenkel created this beautiful image, which is not quite a profile because the far eye is visible to the camera. It's a hybrid pose. Compositionally, he moved his subject off center and used the lines of the tulle drapes to mimic the flowing line of her shoulder. In Photoshop, he softened the background and lightened the entire image, making it a high-key portrait. Note that the downward gaze helps to show her entire eye, and produces a thoughtful and sensitive expression.

► (BOTTOM) The profile is one of the most elegant poses for the human face, particularly when it is combined with elegant lighting, as was done here by Monte Zucker. The natural line of the railing, a strong defining diagonal line, helps raise the little girl's glance upward, which is a very beautiful pose. Normally, the subject's head is rotated until the eyelashes of the far eye disappear, but in this case, her eyelashes are so long, you can still see them if you look closely. Monte used a skimming key light from above and behind the little girl in order to create elegant highlights with excellent detail on her rich skin. A reflector fill, near the camera, washed the shadow side of her face with soft light.

important when posing the sitter in a three-quarter facial view to position him or her so that the small eye (people always have one eye that is slightly smaller than the other) is closest to the camera. This way both eyes appear to be the same size in the final photograph. For more on this topic, see chapter four.

The Two-Thirds View. Many photographers do not recognize the distinction between the above two facial views. Instead, if the pose is not a profile or a head-on shot, then it is referred to as a two-thirds view. The two-thirds view is probably the most frequently used facial position and the most versatile angle with which to photograph the human face. In this view, as in the three-quarter view, you see two full planes of the facial mask, providing the most opportunity to show roundness, dimension, and expression. This view is obtained by turning the subject's head farther than the seven-eighths view, but just short of the profile view. Whether you call it a two-thirds or three-quarter viewpoint, it is important that the eye on the far side of the face appear to be contained within the face by including a small strip of visible skin along the far temple.

The Profile View. In the profile view, the head is turned almost

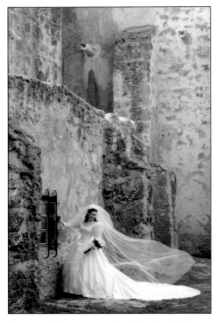

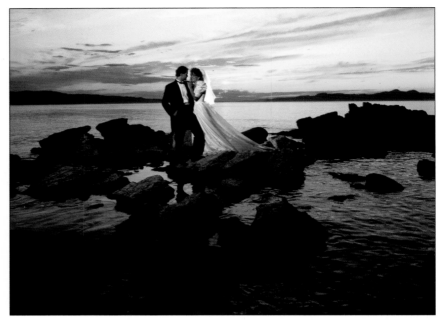

▲ **(LEFT)** This portrait by Elizabeth Homan, entitled *Golden Breeze*, is a major award winner and has received a perfect score in print competition. The image is beautifully posed with elegant lines throughout the composition. The bride's downward glance follows the flowing line of the composition and her expression is priceless.

▲ **(RIGHT)** This is a beautiful full-length portrait by Bill Duncan. Bill told the couple beforehand that they would have to do a little rock-climbing to get the most beautiful portrait. The pose is elegant—each person leaning into one another, the bride's gown creating a beautiful sweep that forms a triangle shape as the focal point of the composition. The groom put his right hand in his pocket, but hitched the thumb so it would not be lost in all the black of his tux.

▶ Monte Zucker created this full-length formal bridal portrait. Note all the basic posing steps in play: the bride is turned 45 degrees to camera, her head is tilted back toward her near shoulder, her elbows are bent, and the bouquet is being held below the waist to create a sufficient triangle base. Her right hand is curved in to surround the bouquet, her weight is on her back foot, and her front foot is extended to improve the line of the dress—the list goes on and on!

90 degrees to the camera, so only one eye is visible. When posing your subject in a profile position, have him or her turn their head gradually away from the camera position just until the far eye and eyelashes disappear from view.

In some cases, especially with women, you will still be able to see the eyelashes of the far eye when the subject is in profile. Instead of turning the head farther to eliminate the eyelashes, retouch them out later.

● REFINEMENTS:
POSING THE BODY

The more of the human body you include in a portrait, the more posing problems you will encounter. When you photograph a person in a three-quarter- or full-length pose, you have arms, legs, feet, hands, and the total image of the body to contend with—not to mention, the all-important expression of the subject.

Three-Quarter-Length Portraits. A three-quarter-length por-

trait shows the subject from the head down to a region below the waist—usually mid-calf or mid-thigh. Never compose a portrait with a "break" (the edge of the frame) at a joint (an elbow, a knee, or an ankle, for instance) as this has an unnerving psychological impact on the viewer.

Full-Length Portraits. A full-length portrait shows the subject from head to toe with usually a fair amount of background or environment included in the portrait. A

full-length shot can show the person standing or sitting, but it is important to remember to slant the person to the lens and to create a triangular base. As noted above, you should avoid photographing the person head-on, as this adds mass and weight to the body and minimizes the possibility of dynamic lines in the pose. Dynamic lines—diagonal lines, triangles, and other asymmetrical shapes—create visual interest within a portrait or grouping and should be an intentional aspect of any pose.

For flattering full-length portraits, the subject's body should be positioned at a 30- to 45-degree angle to the camera. The subject's weight should always be placed on the back foot, rather than being distributed evenly on both feet or, worse yet, on the front foot. If the person is standing, there should be a slight bend in the front knee. This helps break up the static line of a straight leg. If the subject is wearing a dress, a bend in the front knee will also help create a better line to the dress. The back leg can remain straight, since it is much less noticeable than the front leg.

● REFINEMENTS:
POSING THE FEET
Have the feet pointing at an angle to the camera. While it is undesirable to have the hands facing the

▶ Here, the bride leans backward, arching her back. Her hands are outstretched, holding the veil, wrists arched upward. In this pose, the bride usually glances down one arm or the other. In this case, she looks toward the camera and her head is tilted toward the near shoulder. Photograph by Bill Duncan.

lens head-on, this is even more important with the feet. Feet tend to look stumpy when shot head-on. Positioning the feet at an angle to the camera will automatically tilt the body plane to the camera. This is why many portrait and wedding photographers say to begin any standing pose with the feet.

● REFINEMENTS:
POSING THE HANDS
A person's hands are often a strong indicator of character, just as the mouth and eyes are. Posing the hands properly in a portrait can be difficult because they are closer to

the camera than the subject's head, and thus appear larger. One thing that will give hands a more natural perspective is to use a longer lens than normal. Although holding the focus of both hands and face is more difficult with a longer focal-length lens, the size relationship between them will appear more natural. And if the hands are slightly out of focus, it is not as crucial as when the eyes or face are soft.

One basic rule is never to photograph a subject's hands pointing straight into the camera lens, as this distorts the size and shape of the hands. Hands should be posed

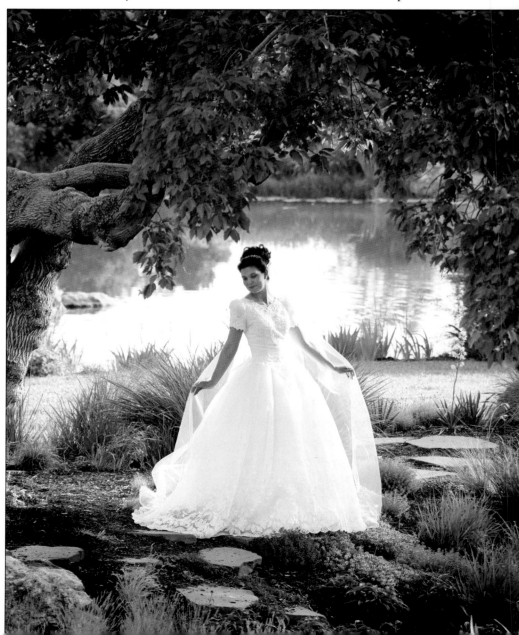

at an angle to the lens. Another basic is to photograph the outer edge of the hand whenever possible. This gives a natural, flowing line to the hand and eliminates the distortion that occurs when the hand is photographed from the top or head-on.

The bend in the wrist joint is called a break. You should always try to break the wrist—meaning to raise the wrist slightly so there is a smooth bend and gently curving line where the wrist and hand join. Also, you should always try to photograph the fingers with a slight separation in between. This gives the fingers form and definition. When the fingers are closed together, the hand looks like a two-dimensional blob.

Flat hands are also unattractive. Fingers turned in on a flat palm can even look like claws. Be sure to have the subjects extend their fingers so that they appear long and graceful, with the edge of the hands toward the camera. Assure the sitter that what may seem or feel awkward to them comes across as quite natural from the camera's viewpoint.

Posing Men's Hands vs. Women's Hands. As generalizations go, it is important that the hands of a woman have grace, and the hands of a man have strength.

When photographing a man's closed hand, it is recommended to give him something small, like the top of a Bic® pen, to wrap his fingers around. This gives roundness and dimension to the hand so that it doesn't resemble a clenched fist.

Having a male subject fold his arms across his chest is also a good strong pose. Remember, however, to have the man turn his hands slightly so the edge of the hand is more prominent than the top of the hand. In such a pose, you should have him lightly grasp his biceps—but not too hard, or it will look like he is cold and trying to keep warm. Also, remember to instruct the man to bring his folded arms out from his body a little bit. This will help to slim down the arms, which would otherwise be flattened against his body and appear larger. Separate the fingers slightly.

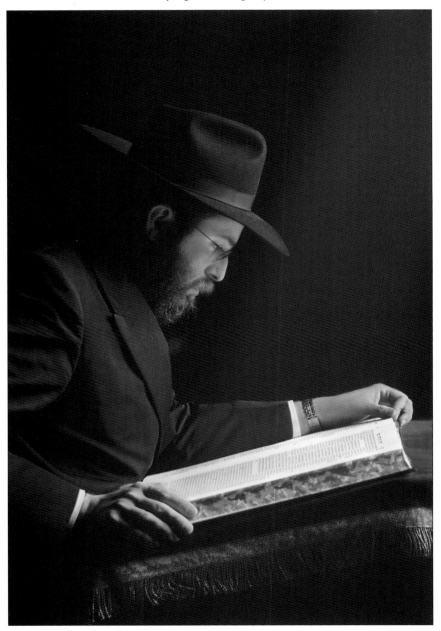

▲ The truth of this man, the Rabbi, is not in his face but in his hands. The right hand, strong and well defined—confident, if you will—holds the Hebrew scriptures firmly. The left hand is poised to turn the page, gently grasping the tiniest corner of the sacred page. The photographer, Giorgio Karayiannis, eliminated all but the fundamental elements of this portrait to convey his feelings about this man.

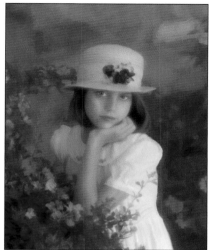

▲ (TOP) Only the edge of the subject's right hand is seen, and it is part of the composition's triangle base. The hand is relaxed, and the shirt cuff produces tonal separation. Note that the hand does not press into the side of the man's head. Portrait by Monte Zucker.

▲ (BOTTOM) The elegant hand posing and tilt of the head of this little girl make this portrait, by Elizabeth Homan, very special. The image was augmented in Painter, giving it a watercolor effect.

► Jeff Smith had the subject place her hand on her hip. Notice the flowing line of the arm, elbow out so that you can see her waistline. The really excellent feature of this pose is the line of the hand—a break at the wrist, and the edge of the hand and fingers arranged elegantly.

With a standing woman, have her place one hand on her hip and the other at her side for a good standard pose. Don't let the free hand dangle, but rather have her twist the hand so that the outer edge shows to the camera. Always

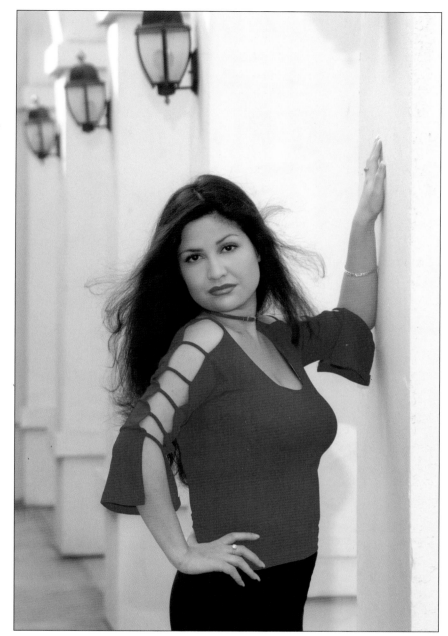

create a break in the wrist for a more dynamic line.

● REFINEMENTS: SEATED POSES
Posing stools and benches are available that allow the subject comfort while providing the proper upright posture. Outdoors, you must find a spot—a patch of grass under a tree or by a fence, for example—that will be comfortable for the duration of the session.

Seated subjects, especially women, should sit forward on a chair or stool that is angled to the camera. Once seated, the subject's weight should be moved forward. Sitting on the edge of the seat will always be more graceful than sitting squarely on it. Posture is better—the spine erect—and the weight is shifted off of the upper thighs, which often photograph thicker than they are in reality. The

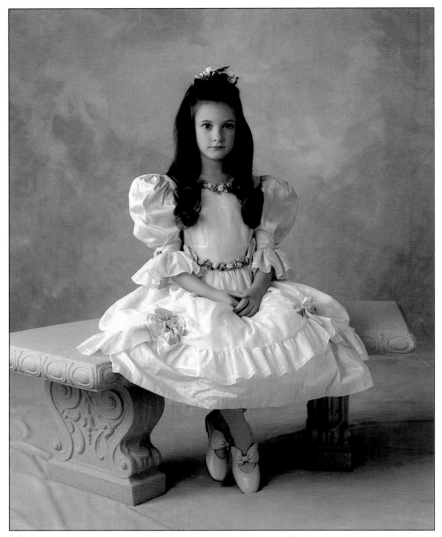

▲ Tim Kelly is an expert at photographing all ages of subjects. This delicate portrait of a seated girl has several highlights. The feet, posed in classic-cross legged fashion, are wonderful, making her look sophisticated beyond her years. The hands, half childlike, half sophisticated, are also defining this young beauty. Her beautiful upright posture and the toe of her shoe almost make her look like a ballerina.

When a man is seated in a portrait sitting, it is usually necessary to check his clothing. The jacket or suit coat, if he's wearing one, should be unbuttoned to prevent it from looking too tight. He should not be sitting on the bottom of the coat, pulling it up in the front. The clothes, especially formalwear, should look comfortable and form-fitting, but should not be pulled or stretched, while sitting. Cuffs should be pulled down in the jacket arms in order to be visible.

A good posing tip for seated subjects: Pose your subject naturally, finding a pose that feels good to the subject. If your subjects are to appear natural and relaxed, then the pose they strike must not only be natural to them, but typical. Monte Zucker, an acclaimed portrait photographer, however, does not put too much stock in this notion, believing that while the subject should *look* comfortable and relaxed, it may be uncomfortable for them to achieve such a pose. He believes in getting the best from his subjects, so he talks them into poses in which they look their best—even if they aren't the most comfortable.

subject's weight should be transferred to the far leg (the one turned away from the camera), thus slimming the leg and thigh most visible to the camera. The subject's posture should be erect with a slight bend forward at the waist.

When the subject is sitting, a cross-legged pose is desirable. Have the top leg facing at an angle and not directly into the camera lens. With women who are sitting,

it is a particularly good idea to have the subject tuck the calf of her front leg (closest to the camera) in behind her back leg. This reduces the apparent size of the calves, since the back leg, which is farther from the camera, becomes the most important, visually. Always have a slight space between the leg and the chair, where possible, as this will slim thighs and calves. This is a pose that women fall into somewhat naturally.

CHAPTER TWO
THE FACE

● FACIAL ANALYSIS

The expert portrait photographer should be able to analyze a subject's face with a brief examination. Under flat light, inspect the subject from straight on and gradually move to the right to examine one side of the face from an angle, and then repeat on the left side. You can do this while conversing with the person, and he or she will feel less self-conscious. In your analysis, you are looking for a number things:

1. The most flattering angle from which to photograph the person. It will usually be at the seven-eighths or three-quarters facial view, as opposed to the head-on or profile view.
2. A difference in eye size. Most people's eyes are not perfectly equal in size. However, both eyes can be made to look the same size by positioning the smaller eye closest to the lens so that natural perspective takes over and makes the smaller eye appear larger

than it actually is because it is closer to the lens.
3. You will notice the face's shape and character change as you move around and to the side of your subject. Watch how the cheekbones become more or less prominent from different angles. High and/or pronounced cheekbones are a flattering feature in both men and women.
4. Look for features to change: a square jaw line may be softened when viewed from one angle; a round face may appear more oval-shaped and flattering from a different angle; a slim face may seem wider and healthier when viewed from head on, and so forth.
5. Examine all aspects of the face in detail and determine the most pleasing angle

from which to view the person. Then, through conversation, determine which expression best modifies that angle—a smile, a half-smile, no smile, head up, head down, etc.

● EYES

The eyes are the most expressive part of the human face. If the subject is bored or uncomfortable, you will see it in his or her eyes. It is essential that the subject's eyes look alive. It is important to light the face in such a way that the iris and pupil are clearly visible and that you are not creating a "deer in the headlights" pose. This can only be judged from the camera position. The more visible the eyes, the more revealing they will be in the portrait. Often, slight changes in the tilt or tip of the subject's head will reveal more of the eyes. Again, this should be evaluated at the camera position.

Active and Alive. The best way to keep the subject's eyes looking active and alive is to engage the person in conversation. Look at the person while you are setting up and

◄ The eyes and the mouth of this portrait are exemplary. Brian King made sure there was a slight white space beneath the iris to exaggerate the color of her eyes. In Photoshop, Brian cleaned up the blood vessels, which everyone has, leaving only a few for realism. Her mouth is pleasant but not smiling. Because they are perfectly shaped, the girl's mouth and eyes are the features the photographer chose to highlight.

► This lovely "overhead" portrait was made by Yervant Zanazanian and highlights the bride's beautiful eyes. The composition is off-center, using the line of the veil to create a strong diagonal within the image. Her eyes, illuminated frontally by daylight, seem to glisten. A short telephoto lens and shallow depth of field guaranteed that the emphasis stayed on the eyes.

try to find a common frame of interest. Everyone loves to talk about themselves, so ask each subject about his or her likes and dislikes, hobbies, family, pets, etc. If the person does not look at you when you are talking, he or she is either uncomfortable or shy. In either case, you have to work to relax your subject and encourage trust. Try a variety of conversational topics until you find one the person warms to, and then pursue it.

As you gain the subject's interest, you will take his mind off the portrait session.

One of the best ways to enliven subjects' eyes is to tell an amusing story. If they enjoy it, their eyes will smile. This is one of the most endearing expressions a human being can make.

Direction of Gaze. A posing tenet that is largely ignored these days is that, for the most graceful look, the direction of the subject's gaze should follow the line of the nose. Often photographers will ignore this rule in favor of adding another dynamic line to the composition, preferring asymmetry to symmetry, a valid reasoning.

Still, the direction the person is looking is important. Start the portrait session by having the subject look at you. Using a cable release or wireless remote with the camera tripod-mounted forces you to become the host and allows you to physically hold the subject's attention. It is a good idea to shoot a few shots of the person looking directly into the camera, but most people will appreciate some variety. Looking into the lens for too long a time will also bore your subject, as there is no personal contact when looking into a machine. Many photographers don't want to stray too far from the viewfinder, so they will look up from the camera to engage the subject just prior to the moment of exposure.

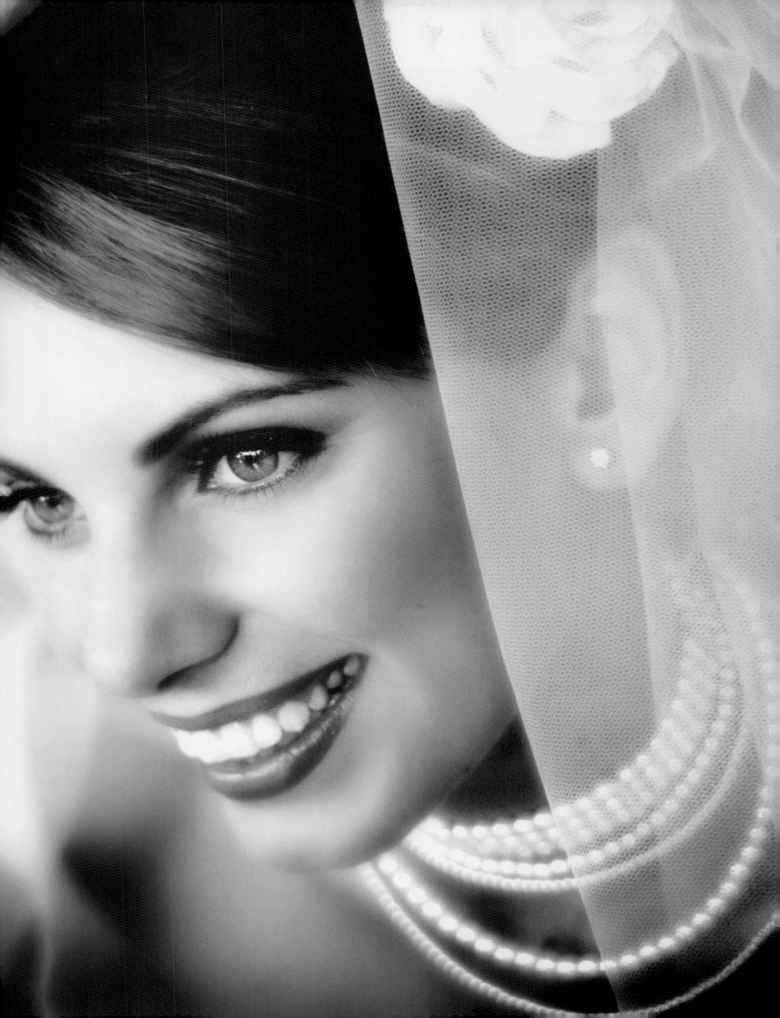

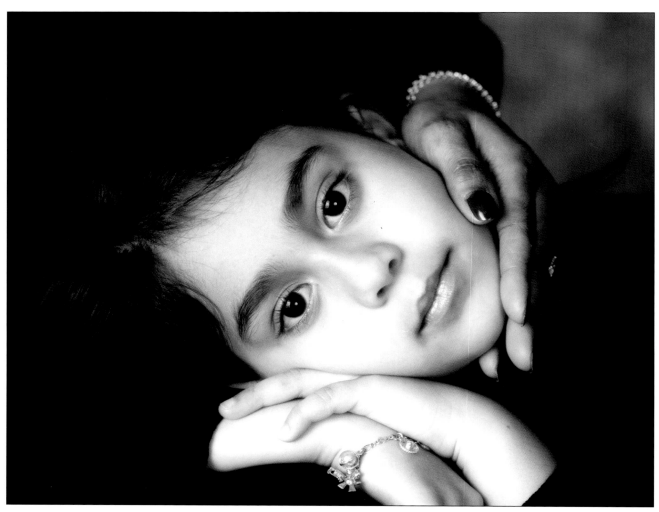

▲ This sweet portrait by Fran Reisner reveals the beauty of this young girl as she is cradled by her mom. The child's hands form a horizontal base, but her eyes are really what this portrait is all about. Fran used a soft main light to the left of the subject and a reflector to the right. The effect is to place two strong catchlights in the eyes, forcing the viewer to inspect the eyes closely.

A piece of advice from Monte Zucker regarding the eyes: "When looking through your lens, check to see if your subject's eyes look completely open. Many times I have my subjects actually looking above the lens when I'm creating their portrait, but in the picture it appears as if they're looking directly into the lens. The only way that you can tell where the subject should be looking is when you, yourself, are looking straight through the lens."

Iris and Pupil. The colored part of the eye, the iris, should generally border on the eyelids. In other words, there should not be a large white space between the top or bottom of the iris and the eyelid. If there is a space, have the subject lower or raise his or her gaze.

Pupil size is also important. If working under bright lights, the pupil will be small and the subject will look "beady-eyed." To correct this, have them shut their eyes for a moment prior to exposure. This allows the pupil to return to a normal size for the exposure.

Just the opposite can happen if you are working in subdued light. The pupil will appear too large, giving the subject a vacant look. In that case, have the subject stare momentarily at the brightest nearby light source to dilate the pupil.

Blinking and Squinting. Some people have a nervous mannerism that causes them to blink almost continuously. To make matters worse, they are often self-conscious of their condition. Try relaxing your subject through music or humor or general conversation, then try to time your exposure after you observe a blink.

People often squint when they smile. They can't help it, as the squinting is related to smiling. An effective antidote is to opt for a non-smiling pose, or a pose with a half-smile instead of a full smile.

Eyeglasses. Some people just don't feel themselves without their eyeglasses. The most effective way to minimize the problems of portraits with eyeglasses is to have the person borrow a pair of glassless frames from his or her optometrist, who many times will lend them to a good customer.

However, if you can't arrange for blanks, you will have to photograph the person the old-fashioned way. If your subject wears eyeglasses, the main light should be positioned at the subject's head height (or slightly higher) and to the side, so that its reflection is not visible in the eyeglasses as seen from the camera. This produces a split or 45-degree lighting pattern. The light should also be diffused so that the eyeglass frames do not cast a shadow that darkens the eyes. The fill light should be adjusted laterally away from the camera until its reflection disappears. If you cannot eliminate the fill light's reflection, try bouncing the fill light off the ceiling.

► In this bridal portrait by Michele Celentano, the hands, the eyes, and the mouth of the bride are posed beautifully. She is in the classic feminine pose, with her head tilted toward the near shoulder. Her mouth is relaxed and turned up but not smiling. Her gaze is not at the camera but beyond it, making her appear lost in thought. The bride's rings are featured prominently, one of the reasons the pose was created in this way.

To reduce reflections, you can also have the person slide his glasses down on his or her nose slightly. This changes the angle of incidence so as to redirect unwanted reflections. Alternately, try turning your subject into the main light and having them tilt their glasses slightly forward; this will often minimize reflections.

When your subject is wearing thick glasses, it is not unusual for the eyes to be darker than the rest of the face. This is because the thickness of the glass reduces the intensity of the light that is transmitted to the eyes. If this happens, there is nothing you can do about it during the shooting session, but the eyeglasses can be dodged during printing (or in Photoshop) to restore the same print density as in the rest of the face.

If your subject wears "photogray" or any other type of self-adjusting lenses, have him keep his glasses in his pocket until you are ready to shoot. This will keep the lenses from getting dark prematurely from the shooting lights. Of

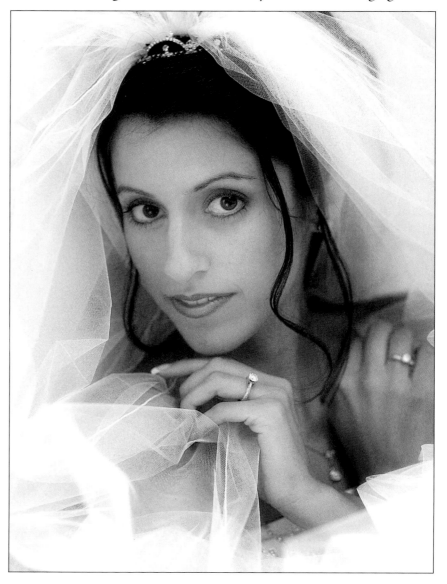

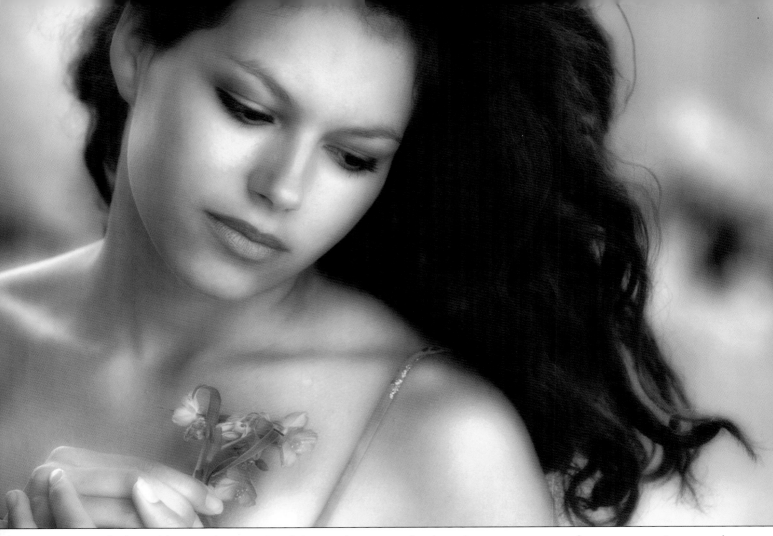

▲ This beautiful portrait by Fuzzy Duenkel uses a low camera height so that you can see into the young woman's eyes as she gazes downward. The bridge of her nose is bathed in a soft highlight that defines its elegant shape. The sides of her nose are in soft shadow, which further enhances its shape. The lighting, all natural, uses a strong directional fill from the right side, which helps to contour all the round planes of the face.

course, once the light strikes them they will darken, so you might want to encourage your subject to remove his or her glasses for the portrait.

One Small Eye. Most people have one eye that is smaller than the other. This should be one of the first things you notice about your subject. If you want both eyes to look the same size in the portrait, pose the subject in a seven-eighths or three-quarters pose and seat the person so that the smaller eye is closest to the camera. Because objects farther from the camera look smaller and nearer objects look larger, this should make both of the eyes appear to be about the same size.

● MOUTHS

Generally, it is a good idea to shoot a variety of portraits, some smiling and some serious (or at least not smiling). People are often very self-conscious about their teeth and mouths, but if you see that the subject has an attractive smile, get plenty of film of it.

Natural Smiles. One of the best ways to produce a natural smile is to praise your subjects. Tell them how good they look and be positive. If you simply say "Smile!" you will produce a lifeless "say cheese" type of portrait. With sincere confidence-building and flattery, you will get subjects to smile naturally and sincerely, and their eyes will be engaged and lively.

Moistened Lips. It will also be necessary to remind the subject to moisten his or her lips periodically. This makes the lips sparkle in the finished portrait, as the moisture produces tiny specular highlights on the lips.

Tension. The sitter's mouth is nearly as expressive as their eyes. Pay close attention to the mouth to

be sure there is no tension in the muscles around it, since this will give the portrait an unnatural, posed look. Again, an air of relaxation best relieves tension, so talk to the person to take his or her mind off the session.

Gap Between the Lips. Some people naturally have a slight gap between their lips when they are relaxed. Their mouth is neither open nor closed but somewhere in between. If you observe this, let them know about it in a friendly, uncritical way. If they forget, politely say, "Close your mouth, please." While this trait is not disconcerting when actually watching the person in repose, when it is frozen in a portrait, the visibility of the subject's teeth through the space between their lips will not be appealing.

Laugh Lines. An area of the face where problems occasionally arise is the frontal-most part of the cheek—the part of the face that creases when a person smiles. Some people have pronounced furrows, or laugh lines, that look unnaturally deep when the subject is photographed while smiling. You should take note of this area of the face. If necessary, you may have to increase the fill-light intensity to avoid creating deep shadows in this area. Alternately, you can adjust your main light to be more frontal in nature. If the lines are severe,

avoid a "big smile" type of pose altogether.

● NOSES

The shape and size of a person's nose can be modified in portraiture—if the photographer is aware of what needs to be corrected. The most obvious thing *not* to do is to photograph a long or large nose in profile. Long noses can, however, be shortened by photographing

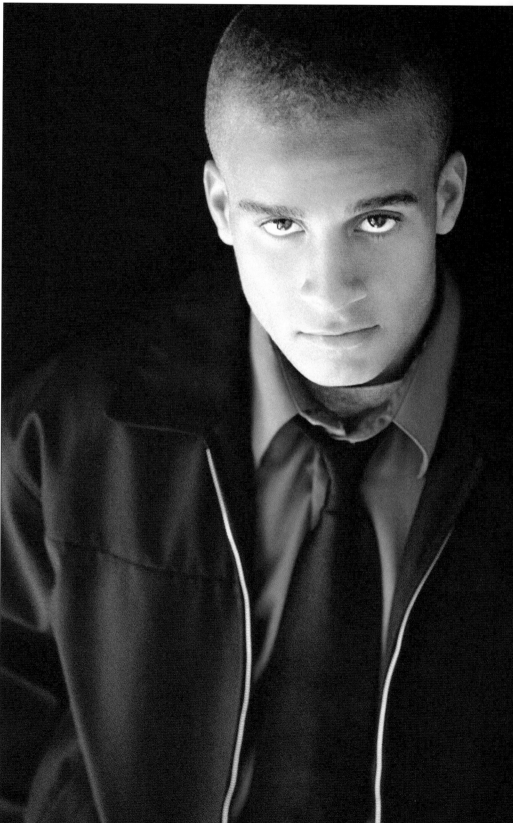

► Brian King positioned the camera at his subject's eye height and had the senior drop his chin to look slightly up at the camera—an unusual pose that accentuates the beauty of this young man's eyes. The effect conveys a sense of confidence and even a little mystery.

from below. Conversely, a short nose can be lengthened by using a higher camera angle.

Crooked noses should be photographed with the subject posed in a three-quarters view, so the crookedness is not visible from the camera position. Another technique for photographing irregularly shaped noses is to use a telephoto lens, which compresses perspective, and photograph the person with their nose pointing directly into the camera. Because of the compressed perspective, the nose takes on less visual prominence.

● CHIN HEIGHT

You should be aware of the psychological value put on facial expressions, such as the height of the subject's chin. If the person's chin is too high, he or she may look haughty. If the person's chin is down, he may seem afraid or lacking in confidence. Beyond the psychological implications, a person's neck can look stretched and elongated if the chin is too high. The opposite is true if the chin is held too low—the person may appear to have a double chin or no neck at all. The solution, as you might expect, is to use a medium chin height. Being aware of the effects of too high or too low a chin height will help you to achieve a good middle ground. When in doubt, ask the sitter if the pose *feels* natural; this is usually a good indicator of what *looks* natural.

● HAIRSTYLE AND MAKEUP

There is no doubt that a fine portrait is enhanced with the appropriate hairstyling and makeup. For women, jewelry is an important part of the equation, as well. Professional hairstyling and makeup are essential to an elegant portrait, but the stylist must be familiar with what works on film. For example, with makeup, a little goes a long way, since the photographic process increases the contrast of the scene. Eye makeup should be blended, with no sharp demarcation lines between colors.

Monte Zucker favors a conservative approach. He says, "Makeup should be almost imperceptible. I usually suggest that a foundation be applied to a woman's face. It should be blended carefully over the jaw line onto the neck. An abrupt color change between the face and neck should be avoided. Mascara is almost always essential. Even women who feel that they don't usually want makeup should be photographed with at least a minimum of mascara. A gloss lipstick is also important, as is eye shadow that defines the eyes but does not call attention to the color of the eyelids."

Bill McIntosh, who does most of his elegant portraits in his clients' homes, pays a visit before the shoot. In addition to determining which room and which props and furnishings will be employed, he uses this time to discuss clothing, jewelry, hairstyle, and makeup with the client. A detailed discussion will help to prevent surprises on the day of the sitting.

For women, many photography sessions begin with the application of photographic makeup by a trained artist. Indeed, many studios employ full- or part-time makeup artists and hairstylists, feeling that their skills are integral to the success of the portrait session. The amount and color of the makeup that will be applied for a session depends on the type of portrait and the outfits selected. Trained experts can add professional touches, such as improving bone structure or the apparent size of a girl's eyes, for example. Makeup can also be used to conceal problem areas. For example, blemishes can be easily handled with ordinary cover-up. A small dab applied to noticeable blemishes will usually make them invisible to the camera.

Some photographers want senior-age girls to do their own makeup. Lipstick is always advised, but a minimal amount of eyeliner is recommended because too much makes the eyes look smaller. It is also a good idea, once the makeup is complete, to finish it off with a matte powder, which reduces shininess and specular reflections.

Advise your clients not to have their hair cut too close to the portrait session. Hair should have a few days to "relax" after a trip to the beauty salon or barber.

► In this image by Robert Lino, the debutante's hair and makeup are decidedly formal, as is the pose. Note the use of the sash, which extends the line of her right arm and hides her elbow, which rests on the table. Note, too, the space between the left arm and her body, a slimming pose. Her left wrist is posed to perfection, with a gentle "break" that extends the flowing line of the corsage. Robert showed only the edge of the subject's hands and posed the fingers so they are separated and graceful.

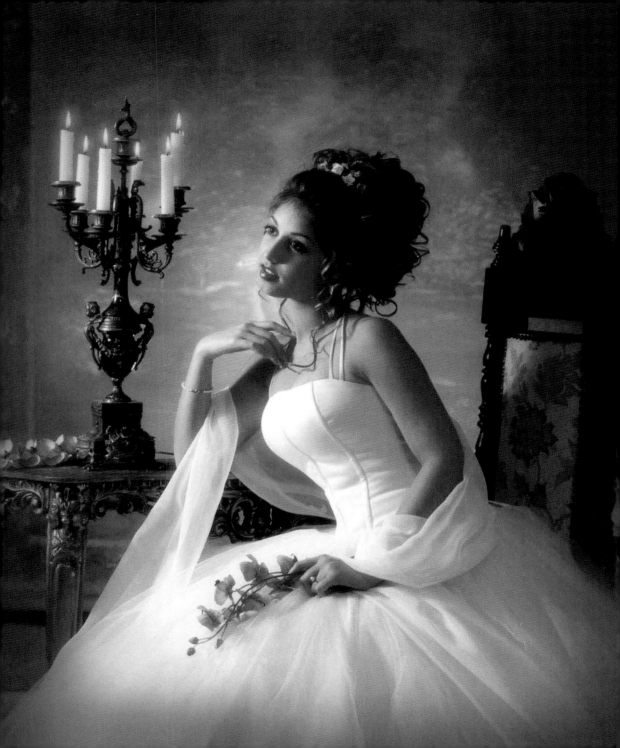

CHAPTER THREE
CAMERA TECHNIQUES AFFECTING POSING

● FOCAL LENGTH AND PERSPECTIVE

Head-and-Shoulders Portraits. The "normal" lens (50mm in the 35mm format, 75–90mm in the medium formats) is not typically used for portraiture because it requires you to get quite close to the subject to provide an adequate image size for a head-and-shoulders portrait. This close proximity exaggerates the subject's features—the nose will appear elongated, and the chin often juts out. The back of the subject's head may appear smaller than normal.

For this reason, portraiture generally demands that you use a longer-than-normal focal length lens on your camera, particularly when shooting head-and-shoulders or three-quarter-length portraits. The rule of thumb is to choose a lens that is twice the diagonal of the film that you are using. For instance, with the 35mm format a 75–85mm lens is a good choice. For the 2¼-inch square format (6x6cm), a 100–120mm lens is fine. For 2¼ x 2¾-inch cameras (6x7cm), a 110–135mm lens is acceptable. These short telephotos provide a greater working distance between the camera and subject while providing normal perspective without subject distortion.

If you have the room, you can use a much longer lens for your head-and-shoulders portraits. A 200mm lens, for example, is a beautiful portrait lens for 35mm because it provides very shallow depth of field and allows the background to fall completely out of focus, ensuring that it won't

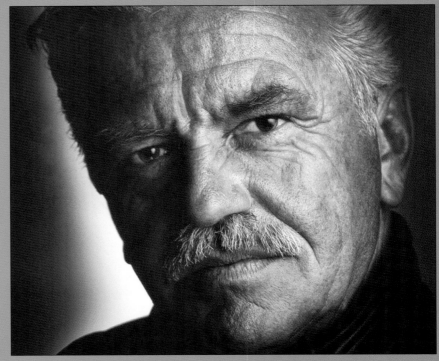

▲ Anthony Cava loves to do tests with people in his neighborhood. This image was recorded with a Nikon D1X and short telephoto lens with strong side lighting and soft fill to bring out the amazing texture of this man's skin.

► The telephoto lens, used wide open, produces very shallow depth of field. David Beckstead created this beautiful high-key image of the bride with an 80–200mm lens used at 120mm with a Nikon D1X. The light was very low and the exposure was only ⅟₁₅ at f/2.8, the maximum aperture of the lens. David adjusted the image in Photoshop to create this very delicate portrait.

distract from the subject. When used at wide-open apertures, this focal length provides a very shallow band of focus that can be used to accentuate just the eyes or just the frontal planes of the subject's face. It can also be used intentionally and selectively to throw certain regions of the face out of focus.

You should avoid using extreme telephotos (longer than 300mm for 35mm), however, for several reasons. First, the perspective becomes distorted—the subject's features may appear compressed, depending on the working distance—the nose often appearing pasted to the subject's face, and the ears of the subject appear parallel to the eyes. Also, since you are a good distance away from the subject with such a long lens, communication is almost impossible. You want to be close enough to the subject so that you can converse normally without shouting out posing instructions.

In some cases, using wide-angle lenses is the only way to make a portrait, either because of space restrictions or because your assignment requires you to incorporate environmental elements in the scene. It is important to avoid subject distortion whenever possible. With wide-angles, this is best accomplished by keeping your sub-

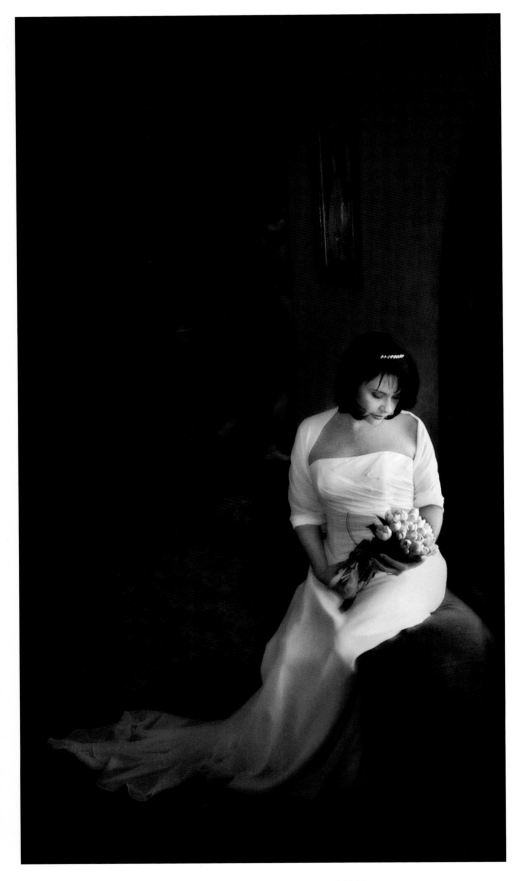

◄ Wide-angle lenses are great tools for portraiture, provided you keep your subject away from the frame edges, where the image will distort. Wide-angle lenses make the foreground intimate and can bring the background into the flow of the composition. Here, a wide-angle portrait by Marcus Bell incorporates a lovely "S" curve composition in the bride and a mysterious figure leaving the room in the background. The foreground is lit by window light; the background is lit by low-level ambient room light.

ject in the center of the frame, where distortion is minimal. The closer the subject is to the frame edges, the more he or she will distort. Heads will elongate and become misshapen, arms and legs will become unusually long. If you find this happening, you may want to switch to an even wider lens that allows you to center your subject in the frame, away from the frame edges. If your subject is in a room or office, try positioning him in the corner of the room so that converging lines lead in toward him at the center of the frame.

Three-Quarter- and Full-Length Portraits. When making three-quarter- or full-length portraits, it is advisable to use the normal focal-length lens for your camera. In this case, the lens will provide normal perspective because you will be working farther away from your subject than when making a head-and-shoulders shot. The only problem you may encounter is that the subject may not separate visually from the background with the normal lens. It is desirable to have the background slightly out of focus so that the viewer's attention goes to the subject, rather

than to the background. With the normal lens, the depth of field is greater, so that even when working at wide lens apertures, it may be difficult to separate the subject from the background. This is particularly true when working outdoors, where patches of sunlight or

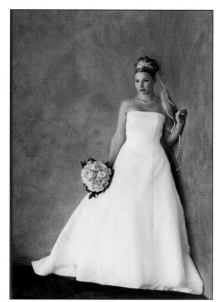

▲ This is a very unusual but effective pose by Anthony Cava. There is no turn to the body, but the bride's head is at an angle and the lighting is superb. Also, there is a nice separation of her arms from her body and her hand is posed uniquely. When you encounter a subject who is either thin or very fit, it is sometimes okay to photograph them square to the camera.

▶ (TOP) Wide-angle lenses are ideal for bringing the environment into the portrait, as was expertly done here by Larry Capdeville. The inherent depth of field of wide-angles make it easy to hold different planes of focus at relatively wide apertures.

▶ (BOTTOM) When photographing full-length portraits, a normal focal length is ideal. It helps to render all the elements in proper perspective. Robert Lino created this amazing portrait with a Bronica SQ-ai and 90mm lens (a little longer than normal), using a combination of room light, window light, and strobe light.

other distracting background elements can easily detract from the subject. One might use Photoshop to diffuse the background in such a situation.

Group Portraits. When making group shots, you are often forced to use wide-angle lenses. While the background problems discussed above can be even more pronounced, using a wide-angle lens is often the only way you can fit the entire group into the frame and still maintain a decent working distance.

● LENSES AND DEPTH OF FIELD
This is a good place to discuss some basic points about lenses and depth of field. First, shorter lenses have much greater inherent depth of field than telephotos. This is why so much attention is paid to focusing telephoto lenses accurately in portraiture. Second, the closer you are to your subject, the less depth of field you will have. When you are shooting a tight face shot, be sure that you have enough depth of field at your working lens aperture to hold the focus fully on the subject's face. Third, medium format lenses have less depth of field than 35mm lenses. A 50mm lens on a 35mm camera will yield more depth of field than the equivalent lens (75mm) on a medium format camera—even if the lens aperture and subject distance are the same. This is important because many photographers feel that if they go to a larger format they will improve the quality of their portraits. While the larger-format image may appear to be improved simply because the film size is larg-

er, focusing will actually become much more critical as the format size increases.

If you are using a film camera, it is important that you check the depth of field with the lens stopped down to your taking aperture, using your camera's depth-of-field preview control. However, since the viewfinder screen is often too dim when the lens is stopped down to gauge depth of field accurately, you should also learn how to read the depth-of-field scale quickly, and practice measuring distances mentally. Better yet, learn the char-

▲ Using a short focal length lens helps tie the background and subject together, particularly when the camera is a long distance away from the subject. Robert Lino captured this classic Quinceañera (debutante) by broad, soft window light. The subject and chair are roughly the width of the large painting in the background, making for a very symmetrical composition. The lone candelabra creates a tension (an off-balance state) that makes this portrait incredibly beautiful.
► The depth of field in this brilliant portrait by Marcus Bell is just barely enough to cover the mask of the bride's face. The aspect of the scene that really intrigued the photographer was the bride's incredible blue eyes, which he highlighted by making everything else soft. The depth of field is so shallow that not even the tip of her nose is sharp.

acteristics of your lenses. You should know what to expect in terms of sharpness and depth of field at your most frequently used lens apertures.

Some digital cameras offer you the ability to make an exposure and then zoom in to inspect the image in close-up detail on the LCD viewfinder on the back of the camera. This feature is much preferred to analyzing the image with the lens stopped down in the viewfinder, where the image may be dark and poorly defined.

● FOCUSING

Head-and-Shoulders Portraits. The most difficult type of portrait to focus precisely is a head-and-shoulders portrait. In this type of image, it is especially important that the eyes and frontal planes of the face be tack-sharp. Often, it is desirable for the ears to be sharp, as well.

When working at wide lens apertures where depth of field is reduced, you must focus carefully to hold the eyes, ears, and tip of the nose in focus. This is where a good knowledge of your lenses comes in handy. Some lenses have the majority of their depth of field behind the focus point; others have the majority of their depth of field in front of the point of focus. In most cases, the depth of field is split evenly; half in front of and half behind the point of focus.

Assuming that your depth of field lies half in front and half behind the point of focus, it is best to focus on the subject's eyes in a head-and-shoulders portrait. This will generally keep the full face and the eyes, the main center of interest, in sharp focus. The eyes are a good point to focus on because they are the region of greatest contrast in the face, and thus make focusing simple. This is particularly true for autofocus cameras that often seek areas of contrast on which to focus.

Three-Quarter- and Full-Length Portraits. Focusing a three-quarter- or full-length portrait is a little easier because you are

◄ Brian King likes to work at wide-open apertures. In this portrait of a high school senior, Brian recorded the mask of the face completely sharp. The hair and even the tip of the nose, however, are starting to fall out of focus. Careful focusing is essential in a portrait, particularly when, as here, the exposure was made by available light and there was very little depth of field.

▲ Forced perspective occurs when the photographer intentionally introduces contrasting foreground and background elements, allowing the viewer to leap from foreground to background. In this portrait by Marcus Bell, the leap is made even more enjoyable by framing the two women in the breakfast nook. The father (or grandfather), in the foreground, is exuding such a priceless expression, indifferent to the background scene, that it creates a beautiful bit of visual irony. The image was recorded with a Canon 1DS and 24mm lens at an exposure of ⅟₆₀ at f/2.8. Note how well the photographer controlled the highlights in both regions of the photo.

farther from the subject, where depth of field is greater. Again, you should split your focus, halfway between the closest and farthest points that you want sharp. And again, because of background problems, it is a good idea to work at wide-open or nearly wide-open apertures to keep your background somewhat diffused.

● CAMERA HEIGHT AND PERSPECTIVE

When photographing people with average features, there are a few general rules that govern the camera height needed to produce a normal perspective.

Head-and-Shoulders Portraits. For head-and-shoulders portraits, the rule of thumb is that the camera should be placed at the same height as the tip of the subject's nose or slightly higher. When

the front of the subject's face is parallel to the plane of the film, the camera will record the image from its best vantage point, in terms of perspective.

Three-Quarter- and Full-Length Portraits. For three-quarter-length portraits, the camera should be at a height midway between the subject's waist and neck. In full-length portraits, the camera should be the same height as the subject's waist.

Raising and Lowering the Camera. In each of the cases described above, the camera is at a height that divides the visible area of the subject into two equal halves in the viewfinder. This is so that the features above and below the lens–subject axis are the same distance from the lens, and thus recede equally for "normal" perspective. As the camera is raised or lowered, the perspective (the size relationship between parts of the photo) changes. By controlling perspective, you can alter the physical traits of your subject.

By raising the camera height in a three-quarter- or full-length portrait, you enlarge the head and shoulders of the subject, but slim the hips and legs. Conversely, if you lower the camera, you reduce the size of the head, and enlarge the size of the legs and thighs.

◄ The combined use of a very wide-angle lens and a low camera angle forces the perspective of this image. The foreground and background are made prominent by the use of the wide-angle and compositionally tie the church and Rolls to the bride and groom. It is important to note that when picturing people with very wide-angle lenses, one must keep them away from the frame edges to avoid distortion. Photograph by Larry Capdeville.
◄ Vladimir Bekker photographed both of the portraits in this composite from below chin height, a tactic he felt rendered the bride's face as an ideal oval. In both instances, the lenses used were short telephotos. Normally, you would photograph a head-and-shoulders portrait from nose height to avoid feature distortion.

Tilting the camera down when raising the camera (or up when lowering it) increases these effects. A good rule of thumb is that for three-quarter- or full-length portraits, you should keep the lens at a height where the plane of the camera's back is parallel to the plane of the subject. If the camera is tilted upward or downward, you will be distorting the person's features.

When you raise or lower the camera in a head-and-shoulders portrait, the effects are even more dramatic. Therefore, adjustments in camera height, positioning the camera either above or below nose height, are a prime means of correcting facial irregularities. Raising the camera height lengthens the nose, narrows the chin and jaw lines, and broadens the forehead. Lowering the camera height shortens the nose, de-emphasizes the forehead, and widens the jaw while accentuating the chin.

Distance to Subject. The closer the camera is to the subject, the more pronounced the changes in camera perspective are. If you find that after you make a camera-height adjustment for a desired effect there is no change, move the camera in closer to the subject and observe the effect again.

Ideally, you want the camera to see an undistorted, flattering view of the face and body. Monte Zucker's procedure for adjusting camera height is to first place the camera at the height needed for the amount of the body that is showing. Then he looks through the viewfinder while making final adjustments to his subjects. "I will adjust the subject's face up or

▲ Clay Blackmore created this classic three-quarter-length bridal profile with backlight and a low camera angle. While the camera viewpoint is lower than normal, it is still close to splitting the scene halfway between top and bottom. The slightly lower camera angle accents the width and grandeur of the wedding gown.

down and/or side to side to look its best," he notes.

● TILTING THE CAMERA

In the new brand of portraiture, you will often see the camera tilted for dynamic effect. This technique flies in the face of convention, but it has more than just a fine-art effect. Tilting the camera, for instance, may allow the photographer to raise or lower the line of the shoulder, for a more pleasing pose. With wide-angles, tilting the camera may shift the subject's face away from frame edges, causing

less distortion in the crucial areas of the image, but still allowing the pictorial effects of the wide-angle to be enjoyed.

● SHOOTING APERTURES

Choosing the working lens aperture is often a function of exposure level. In other words, sometimes you don't have much of a choice in the aperture you select—especially when you are using electronic flash or shooting outdoors.

When you have a choice, optics experts say to choose an aperture that is 1½ to 2 full stops smaller than the lens's maximum aperture. For instance, the optimum lens aperture of an f/2 lens would be around f/4. Fuzzy Duenkel, a noted senior photographer from Wisconsin, shoots most of his portraits with an 80–200mm f/2.8 lens stopped down to f/4. He stops down one stop to cover autofocusing errors and because it is

closer to the lens's optimum taking aperture.

The optimum aperture, however, may not always be small enough to provide adequate depth of field for a head-and-shoulders portrait, so it is often necessary to stop down. These apertures are small enough to hold the face in focus, but not small enough to pull the background into focus. They usually also provide a fast enough shutter speed to stop subtle camera

▲ Marcus Bell created this lovely and well designed wedding portrait by tilting the camera to provide a beautiful diagonal line that instantly creates visual interest. The elements of the bicycle and palm trees provide a fitting frame for this playful image. Marcus fired a flash from the camera position to open up detail in the backlit bride and groom.

◀ (FACING PAGE) Kevin Kubota created this wide-angle image while sitting up on the back seat of the convertible. In this wild ride with the bride and groom, note where the yellow lines are and how there is just enough camera movement to provide a little extra visual tension. Not doubt this reflects the emotional tension of the photographer!

or subject movement. Note that the use of optimum lens apertures is dependent on the overall light level and the speed of the film you are using.

Shooting Wide Open. A technique that has been perfected by sports photographers and other photojournalists is to use the fastest possible shutter speed and widest possible lens aperture. The technique does two things—quells all possible subject and camera movement and, depending on the camera-to-subject distance, allows the background to fall completely out of focus. When using telepho- to lenses and working up close to a subject, the effects are even more exaggerated, creating razor-thin planes of focus on the face, with

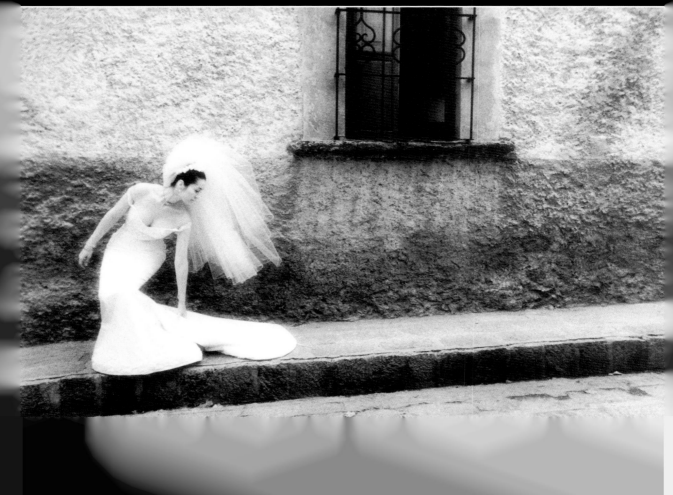

◀ (TOP) This beautiful portrait, reminiscent of the 1940s, was made by Joe Buissink, who chose a relatively wide shooting aperture to hold the bride in focus but eliminate the focus on the groom so that he becomes an adoring spectator.

◀ (BOTTOM) When the bride reached back to pick up the train of her wedding gown, Joe Buissink made a single exposure of this extraordinary moment. Is it a portrait? You bet—one born of timing and reflexes and as telling as the most carefully posed portrait. Being prepared means you often shoot wide open at the fastest shutter speed available to you.

▶ Many photographers find even the limited depth of field provided by working at f/2.8 to be too wide. They prefer a razor-thin band of focus created by defocusing areas of the image in Photoshop or in the darkroom. Such is the case with this classic bridal portrait by Joe Buissink. Here, the eyes are sharp, but not much else is. Even the veil and hair are coming out of focus to create a dreamy high-key portrait of a very beautiful bride.

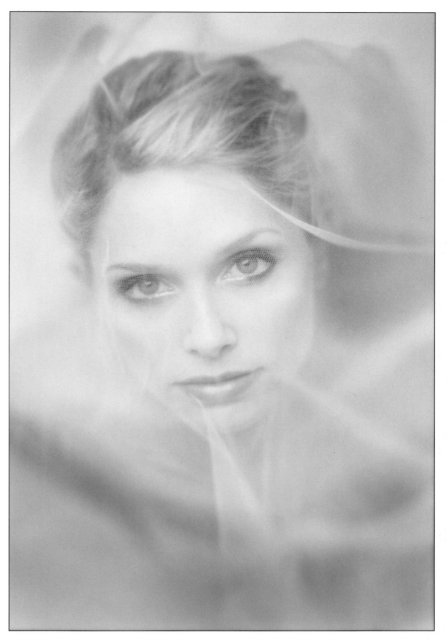

clear lines of defocus visible. It is a stylized effect that has gained much popularity of late.

● SHUTTER SPEEDS

You must choose a shutter speed that stills camera and subject movement. If you are using a tripod, $\frac{1}{30}$ to $\frac{1}{60}$ second should be adequate to stop average subject movement.

Dragging the Shutter. If you are using electronic flash, you are locked into the flash sync speed your camera calls for unless you are "dragging" the shutter, meaning that you are working at a slower-than-flash-sync shutter speed to bring up the level of the ambient light in the exposure. This technique is used to create a flash expo-sure balanced with the ambient light exposure. In the world of fashion, the same technique is used to add impact, since the flash freezes the subject while the slow shutter speed blurs any subject movement.

Outdoors. When working outdoors, you should generally choose a shutter speed faster than $\frac{1}{60}$ second, because slight breezes will cause the subject's hair to flut-ter, producing motion during the moment of exposure.

Handholding. If you are not using a tripod, the general rule is to use the reciprocal of the focal length of the lens you are using for a shutter speed. That is about the slowest shutter speed with which you can effectively handhold an exposure and get it sharp. For instance, if using a 100mm lens, use $\frac{1}{100}$ second (or the next highest

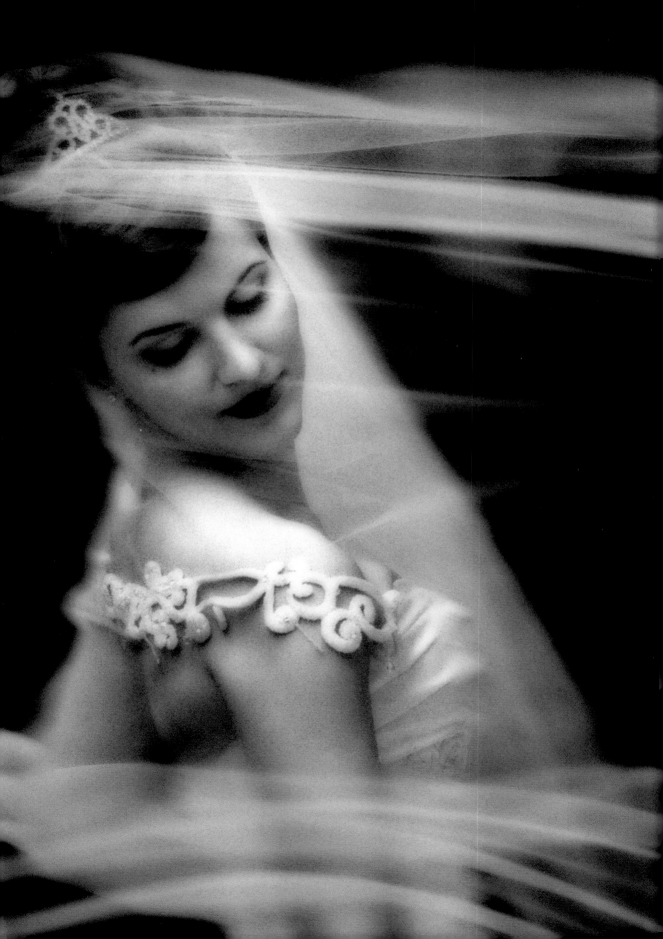

equivalent shutter speed, like $\frac{1}{125}$) under average conditions. If you are very close to the subject, as you might be when making a tight face shot, you will need to use an even faster shutter speed because of the increased image magnification.

Subjects in Motion. When shooting candid portraits or when your subject is moving, choose a shutter speed fast enough to still subject movement. If you have any question as to which speed to use, always use the next fastest speed to ensure sharp images. It's more important to freeze the subject's movement than it is to have great depth of field for such a shot.

Image Stabilization Lenses. One of the greatest enhancements in lens design has been the advent of the image stabilization lens, which counteracts camera movement, allowing the photographer to shoot at impossibly slow shutter speeds of $\frac{1}{15}$ or $\frac{1}{8}$ second without

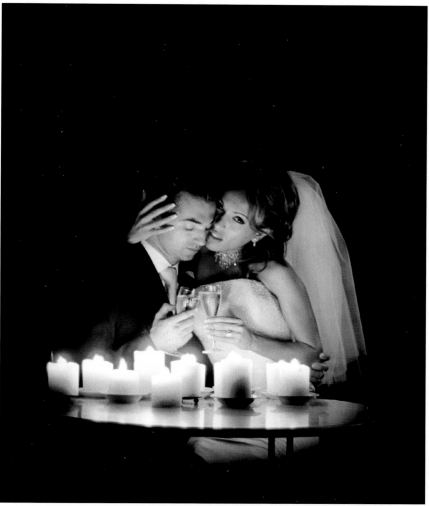

◄ A fast shutter speed and a fabulous eye helped Yervant Zanazanian isolate this bride from her windblown veil. Yervant had the bride lean back and look down, arching her back in order to create a beautiful line to the portrait. The stationary part of the veil created a lovely diagonal line through the composition. The depth of field in the image was minimal, and some additional retouching was done in Photoshop.

► (TOP) Jerry Ghionis captured this beautiful romantic portrait by candlelight using a wide-open lens aperture and very long shutter speed of $\frac{1}{8}$ second. As you can see by the green in the veil, which is strangely beautiful, Jerry picked up a little stray light, probably fluorescents, from elsewhere in the room.

► (BOTTOM) This scene, photographed by Joe Buissink, was literally impossible to meter—a field of black and a spotlit bride and groom in the midst of their first dance. Joe let the camera meter take care of the tough stuff—using a center-weighted reading metered for the bride and groom, and ignoring the huge black area.

encountering any image-degrading camera movement. Such lenses provide the ability to shoot in low light at maximum apertures and still obtain sharp images at relatively long shutter speeds. Currently Nikon and Canon offer such lenses for their systems.

● A WORD ABOUT DIGITAL CAPTURE

The number of photographers now capturing images digitally is increasing by leaps and bounds. Digital film speeds correlate closely to actual film speeds—the slower the film speed setting, the less noise (the digital equivalent of grain) and the more contrast. Digital film speeds can be increased or decreased between frames making digital capture inherently more flexible than shooting film, where you are locked into a single film speed for the duration of the roll.

Shooting at higher speeds, like ISO 1600, produces a lot of digital noise in the exposure. Many digital image-processing programs contain noise-reduction filters that automatically function to reduce noise levels. New products, such as nik multimedia's Dfine, a noise reducing plug-in filter for Adobe Photoshop, effectively reduce image noise, post-capture.

Camera systems have evolved to the point where they can produce a very high number of good exposures under difficult situations. However, professionals are continually pushing the envelope. Digital exposures are not nearly as forgiving as color negative film, for example. The exposure latitude is simply not there. One master pho-

▲ Marcus Bell created this thoroughly delightful portrait of a mother and daughter on her wedding day. It is certainly not a posed portrait, but telling, nonetheless. Marcus used a Canon 1DS and 70–210mm EOS lens at a film speed of ISO 400. He enhanced the grain in Photoshop. The original exposure, despite the low light, was made at 1/250 at f/4.7 to create enough depth of field to hold the focus on both faces.

tographer, Tim Kelly, compares shooting digitally to shooting transparency film, in which exposure latitude is usually ½ stop or less.

With transparency film, erring on either side of correct exposure creates trouble. When shooting digitally, however, exposures on the underexposed side are still salvageable (particularly when shooting in the RAW format), while overexposed images, where there is no highlight detail, are all but lost forever. You will never be able to restore the highlights that don't exist in the original exposure. For this reason, most digital images are exposed to ensure good detail in the full range of highlights and midtones, and the shadows are either left to fall into the realm of underexposure or they are "filled in" with auxiliary light to boost their intensity.

CHAPTER FOUR
COMPOSITION TECHNIQUES

Composition in portraiture involves proper subject placement within the frame. There are several schools of thought on proper subject placement, and no one school is the only answer. Two formulas are given here to help you best determine where to place the main subject in the picture area.

● THE RULE OF THIRDS

Many a journeyman photographer doesn't know where to place the subject within the frame. As a result, these less experienced artists usually opt for putting the person in the center of the picture. This is the most static type of portrait you can produce.

The easiest way to improve your compositions is to use the rule of thirds. This is a system that imposes asymmetry into the design of the portrait image. Examine the diagram on page 56. The rectangular viewing area is cut into nine separate rectangles by four lines. The points at which any two lines intersect is considered an area of dynamic visual interest. The intersecting points are ideal spots at

which to position your main point of interest, but you could also opt to place you point of interest anywhere along one of the dividing lines.

In head-and-shoulders portraits the eyes are the point of central interest. Therefore, it is a good idea if they rest on a dividing line or at an intersection of two lines.

In a three-quarter- or full-length portrait, the face is the center of interest thus, the face should be positioned to fall on an intersection or on a dividing line.

In a vertical print, the head or eyes are usually two-thirds up from the bottom edge of the image. Even in a horizontal composition, the eyes or face are usually in the top one-third of the frame, unless the subject is seated or reclining. In

▲ A classic composition using a main triangle shape (horses, couple, driver) and expert positioning of important subject areas in different quadrants of the image. This image is from an award-winning album by Jerry Ghionis.

termine the proportions of the golden mean for both horizontal and vertical photographs.

● DIRECTION

Sometimes you will find that if you place the main point of interest on a dividing line or at an intersecting point, there is too much space on one side of the subject and not enough on the other. Obviously, you would then frame the subject so that the subject is closer to the center of the frame. It is important, however, that the person not be dead center, but to either side of the center line.

Regardless of which direction the subject is facing in the photograph, there should be slightly more room in front of the person (on the side toward which he is facing). For instance, if the person is looking to the right as you look at the scene through the viewfinder, then there should be more space to the right side of the subject than to the left of the subject in the frame. This gives the image a visual sense of direction.

Even if the composition is such that you want to position the person very close to the center of the frame, there should still be slightly more space on the side toward which the subject is turned.

that case, they could be at the bottom one-third line.

● THE GOLDEN MEAN

A compositional principle similar to the rule of thirds is the golden mean, a concept first expressed by the ancient Greeks. Simply, the golden mean represents the point where the main center of interest should lie, and it is an ideal compositional type for portraits.

The golden mean is found by drawing a diagonal from one corner of the frame to the other. Then, draw a line from one or both of the remaining corners so that it intersects the first line perpendicularly (see the diagram shown above). By doing this you can de-

The same compositional principle also applies when the subject is looking directly at the camera. Rather than centering the subject in the frame, you should leave slightly more room on one side to create a sense of direction within the portrait.

● LINE

To effectively master the fundamentals of composition, the photographer must be able to recognize real and implied lines within the photograph. A real line is one that is obvious—a horizon, for example. An implied line is one that is not as obvious; the curve of the wrist or the bend of an arm is an implied line.

Position of Lines. Real lines should not intersect the photograph in halves. This actually splits the composition into halves. It is better to locate real lines at a point one-third into the photograph. This weights the photograph more interestingly.

At the Edge of the Frame. Lines, real or implied, that meet

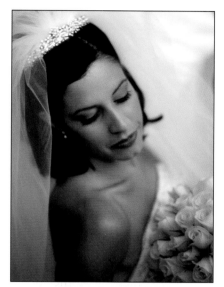

◄ This attractive photograph by Michele Celentano uses powerful diagonal lines to create a strong composition. Positioning the bride at an angle with the bridge of her nose creating a long implied diagonal establishes direction in the portrait. The contrasting diagonal line of her shoulder and the line of her bodice creates a tension in the image that keeps you involved.

▼ This portrait by Ann Hamilton has great animation and feeling, despite the fact that we can't even see the bride's face. We see her great attention to detail and style in every facet of her gown. We see the quirky twist of the fingers as she deftly holds her veil, and we get the sense she is hurrying—perhaps because of the tilted camera and her forward-in-the-frame positioning. It's a gorgeous image.

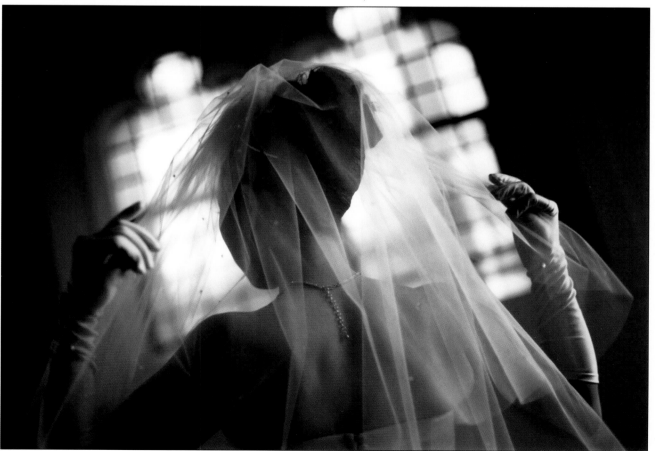

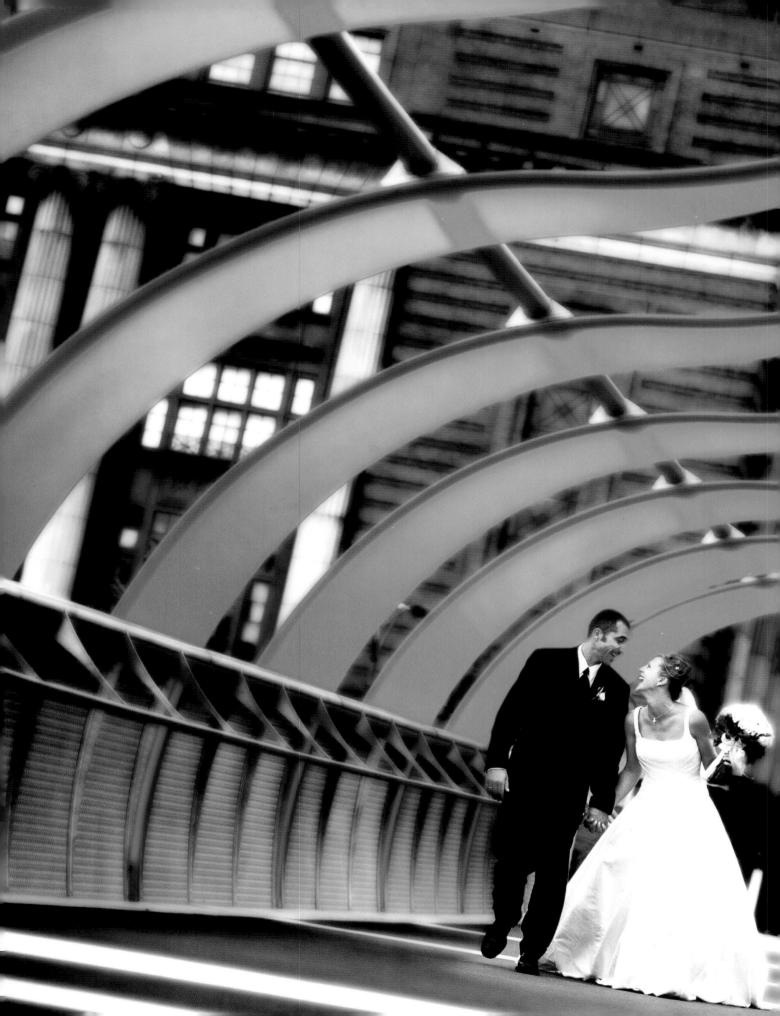

▲ The Thames, Big Ben, darkness suddenly falling at 11 p.m. in late June—these are all icons of London. Photographer Jerry Ghionis used a panoramic diagonal line to define both the longevity of London's landmarks and the intensity of this couple's affection for each other. It is a striking combination of emotions organized along a powerful graphic line in the composition.

▶ Is this composition disturbing or compelling? When I first saw this new image by master photographer Monte Zucker, I wasn't so sure. In traditional posing, one never does this sort of thing—obscuring the face with hands and fingers and fingernails. And yet, the image invites you to inspect it—to look at it long after you've digested the obvious. I decided that it's compelling because of all of the different lines and implied shapes and because it's like looking at someone through a spider's web—you have to work at it to get it.

◀ The dramatic diagonal and flamboyant arch of this bridge drives all of the attention back to the bride and groom—a great example of using found forms to modify and enhance your compositions. Photograph by Jerry Ghionis.

the edge of the photograph should lead the eye into the scene and not out of it, and they should lead toward the subject. A good example of this is the country road that is widest in the foreground and narrows to a point where the subject is walking. These lines lead the eye straight to the subject.

Direction. Implied lines, such as those of the arms and legs of the subject, should not contradict the direction or emphasis of the composition, but should modify it. These lines should feature gentle changes in direction and lead to the main point of interest—either

▲ While this image appears very symmetrical, there are great dynamics of space and movement going on in this image. The background and foreground are two distinct and interesting triangle shapes. In addition, the horse and rider are not dead-center in the image, but to the left of center, in the act of moving toward the right of the image. Photograph by Deanna Urs.

the eyes or the face. There should also be some sort of inherent logic in the arrangement of elements within the image that causes the eye to follow a predetermined path. This is a key element in creating visual interest and staying power.

● LINES AND VISUAL MOTION

Lines in compositions provide visual motion. The viewer's eye follows the curves and angles of these forms as it travels logically through them, and consequently, through the photograph. The recognition and creation of compositional lines, often through posing, is a powerful tool for creating a dynamic portrait.

The S-shaped composition is perhaps the most pleasing of all the forms. In images that employ this shape, the center of interest will usually fall on or near one of the intersections established by the rule of thirds or golden mean, but the remainder of the composition will form a gently sloping S shape that leads the viewer's eye to this area of main interest.

Another pleasing type of composition is the L shape or inverted

L shape. This type of composition is ideal for either reclining or seated subjects.

The C and Z shapes are also seen in all types of portraiture and are both visually pleasing.

● SHAPES

Shapes can be made up of implied or real lines. For example, a classic way of posing three people is in a triangle or pyramid shape. You might also remember that the basic shape of the body in any well-composed portrait resembles a triangle. Shapes, while more dominant than lines, can be used similarly to unify and balance a composition. Subject shapes created through posing can be contrasted or modified with additional shapes

► The wall in these ruins is subdued and the window shape not obvious until you step back and see it is a large arrow pointing upward. The bride's body is arched, looking back and capturing our attention. She is positioned near an intersection in the rule-of-thirds grid. Photograph by Elizabeth Homan.

▼ (LEFT) Knowing that triangles are among the most pleasing shapes in all of art, Bill Duncan incorporated a number of them in this composition. In Bill's words, "This is a little boy fishing on one side of the pond at Red Butte Garden [Salt Lake City, Utah]. I utilized a long lens (500mm) and the RB-67 to reach over the distance. The boy's father was standing just off to the left of the image ready to jump in if his boy fell in. Use caution always. I love the long lenses and how they translate imagery."

▼ (RIGHT) This image, based on a triangular compositional form, was made by Bill Duncan. The bride is actually sitting on a tiny stool, which Bill acquired at a thrift shop. Her knees are dropped down so they don't pop up through the dress, a posing trick that provides a clean line to the gown when brides are seated.

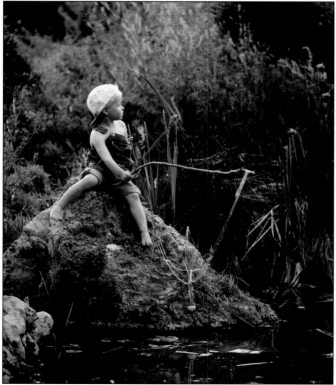

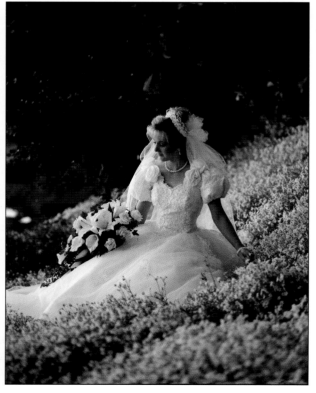

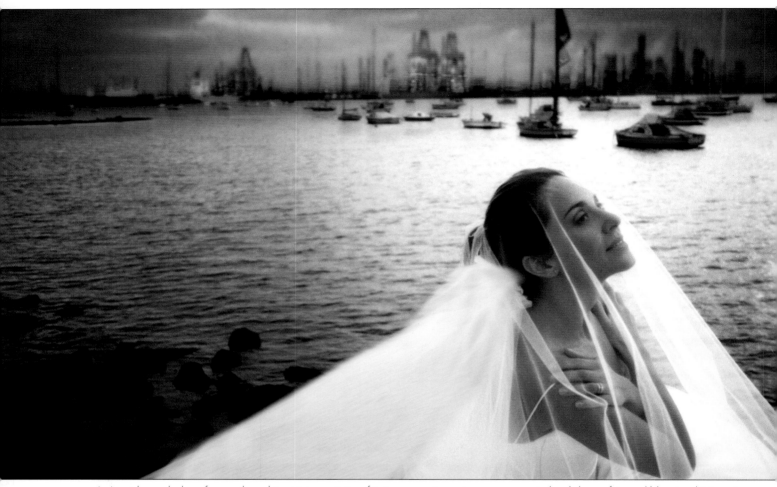

▲ A wide-angle lens forces the subject into a state of intimacy, yet creates a panoramic backdrop of incredible visual interest. Yervant Zanazanian has created a wonderful posed portrait featuring a lovely pyramid shape of the bride against a combination of yachts and industrial light and magic. The bride's pose is vintage 1940s—elegant and romantic. Made at a marina, the far background is the city of Melbourne and the closer background is the oil refinery chimneys of Altona. It was an autumn sunset, as you can see from the sun glowing on the refinery chimneys.

► Why position the bride and groom so far off-center in the composition? Jerry Ghionis decided to set up an equation of visual tension and balance with the bride and the background, which is very powerful by virtue of its color. If you let your eye roam through the image, it will bounce from the bride's face to the crimson red background, down to the sparkly lights, and back to the bride.

found either in the background or foreground of the image.

The classic pyramid shape is one of the most basic in all art and is dynamic because of its use of diagonals with a strong horizontal base. The straight road receding into the distance is a good example of a found pyramid shape.

There are an infinite number of possibilities involving shapes and linked shapes and even implied shapes, but the point of this discussion is to be aware that shapes and lines are prevalent in well composed images and that they are a vital tool in creating strong visual interest and unity within a portrait.

● TENSION AND BALANCE

Just as real and implied lines and real and implied shapes are vital parts of an effectively designed image, so are the "rules" that govern them—the concepts of tension and balance.

Balance occurs when two items, which may be dissimilar in shape, create a harmony within the photograph because they are of more or less equal visual strength.

Tension, on the other hand, is a state of imbalance in an image; it

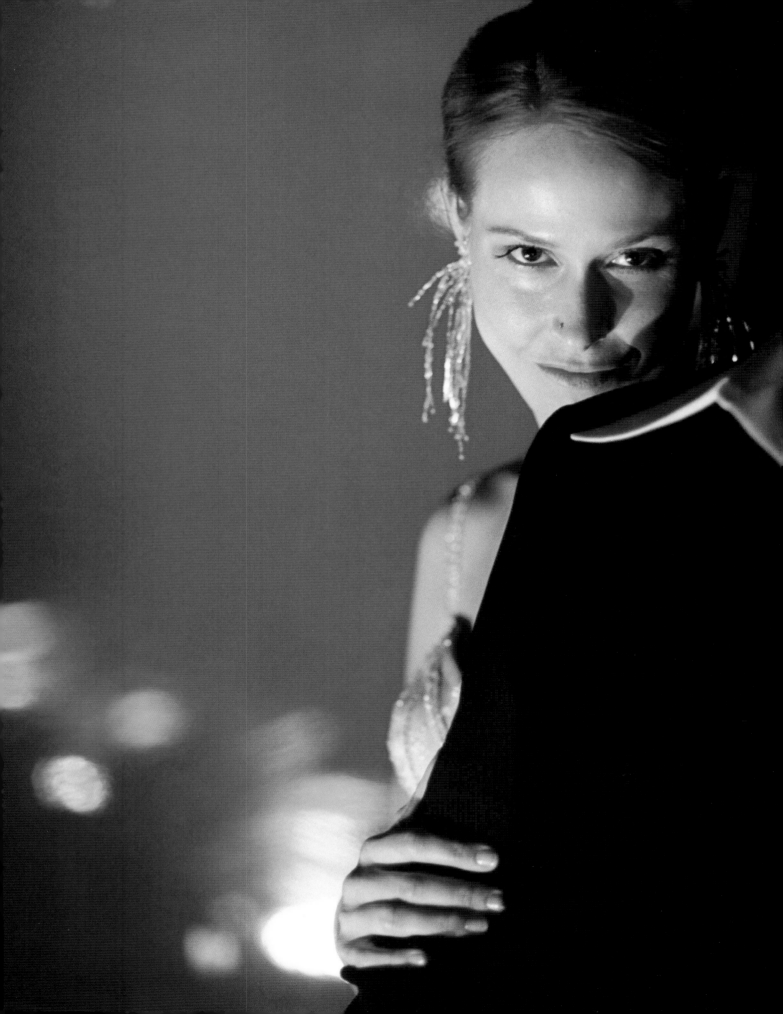

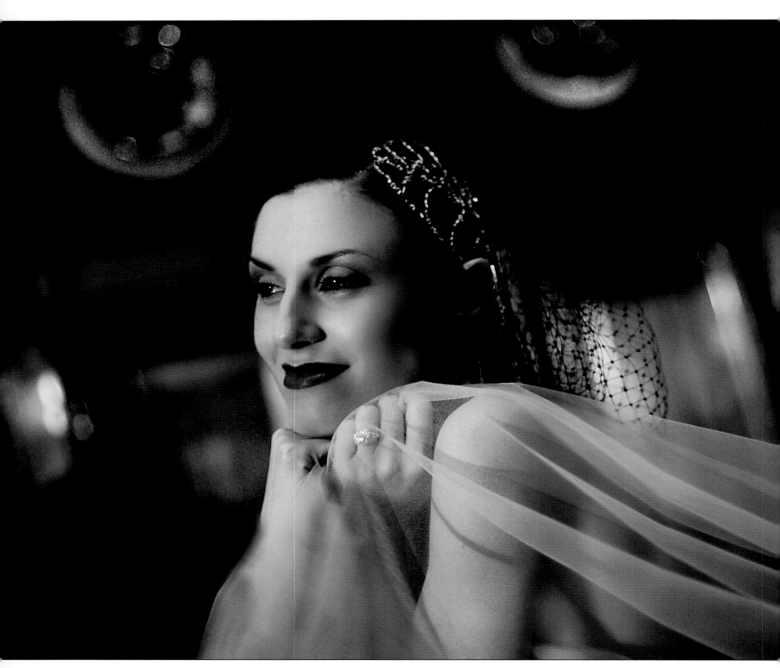

can be referred to as visual contrast. For example, a group of four children on one side of an image and a pony on the other side of the image produce visual tension. They contrast each other because they are different sizes and they are not at all similar in shape.

But the photograph may be in a state of perfect visual balance by virtue of what falls between these two groups or for some other reason. For instance, using the same example, these two different groups could be resolved visually if the larger group, the children, are wearing bright clothes and the pony is dark colored. The eye then sees the two units as equal—one demanding attention by virtue of size, the other gaining attention by virtue of brightness.

Although tension does not have to be resolved in an image, tension works together with the concept of balance so that, in any given image, there are elements that produce visual tension and elements that produce visual balance. This is a vital combination of artistic elements because it creates a sense of heightened visual interest. For this reason, both balance and

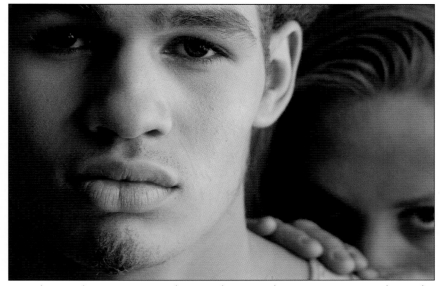

◄ When a subject is positioned across the center line in a composition, he or she is not in the "act of becoming" but is out of balance—at least that's the way the eye sees it. However, when the photographer moves his subject intentionally past that center point, a state of imbalance is achieved. In this image by Yervant Zanazanian, the imbalance seems to imply that the journey is over, and more importantly, it seems to say, "I've arrived!" A video light held by Yervant's assistant provided the superb lighting in this image.

▲ The title of this portrait by Jennifer George Walker is *Property*. The young man, by virtue of subject tone, placement, and sharpness, is dominant in the composition. The girl is out of focus, darker, and mysterious—not defined and somewhat ambiguous. The issue of dominance is a recurring theme in the photographer's portraits.

visual tension are active ingredients in great portraiture.

● VISUAL EMPHASIS

When evaluating the tension and balance in an image, it is important to keep in mind the visual weight of the key elements in the composition, as well as the weight of other elements that could become distractions.

Subject Tone. The eye is drawn, generally speaking, to the lightest part of a photograph. The rule of thumb is that light tones advance visually, while dark tones retreat. It is a natural phenomenon. Therefore, elements in the picture that are lighter in tone than the subject will be distracting. Bright areas, particularly at the edges of the photograph, should be darkened either in printing, in the computer, or in-camera (by vignetting) so that the viewer's eye is not led away from the subject.

Of course, there are portraits where the subject is the darkest part of the scene, such as in a high-key portrait with a white background. This is really the same principle at work as above, because

the eye will go to the region of greatest contrast in a field of white or on a light-colored background. Regardless of whether the subject is light or dark, it should dominate the rest of the photograph either by brightness or by contrast.

A knowledge of the visual emphasis of tone should also be included in your discussions with portrait subjects about the selection of clothing for the session. For instance, darker clothing helps to blend bodies with the background, so that faces are the most prominent part of the photograph. Dark colors tend to slenderize, while light colors add weight. The color of the clothing should be generally subdued, since bright colors attract attention away from the face.

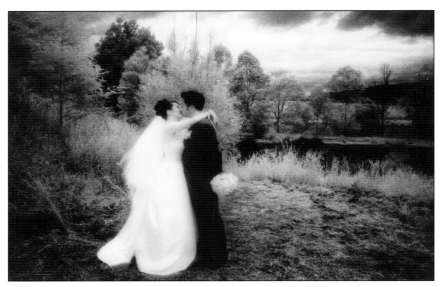

▲ The composition and design are perfect in this image by Mercury Megaloudis. The bride and groom, positioned on the golden mean, are dynamic and dominant. The dark tones on each edge of the print push inward and lead your eye back to the couple. Notice the perfect S shape of the bride and her gown—it's one of the most pleasing forms in all of art and photography.

Prints and patterns—no matter how small—also become a distraction by virtue of their contrast.

Focus. Whether an area is in focus or out of focus has a lot to do with the amount of visual emphasis it will receive from the viewer. For instance, imagine a subject framed in green foliage through which part of the bright sky is visible. The eye would ordinarily go to the sky first. But if the sky is soft and out of focus, the eye will revert back to the area of greatest contrast, hopefully the face. The same is true of foreground areas. Although it is a good idea to make them darker than your subject, sometimes you can't. If the foreground is out of focus, however, it will detract less from a sharp subject.

● THE CONCEPTS OF DESIGN
The above concepts are not unique to photography, but can be found in all forms of visual expression dating back to ancient Greek civilization. While not all photographers are aware of them, they sometimes inherently use them because they have an innate sense of design. For those of us who do not, these principles can be studied and observed in all forms of visual art. The more you become familiar with the visual rhythms that govern how people perceive images, the more practiced you will become in incorporating these elements into your photographs.

How is this relevant to the art of posing, you might ask? The forms of effective visual communication work on both an obvious and a subliminal level and influence the viewer observing a portrait. One can quantify the technical aspects of a photograph, but one may not always be able to verbalize the reasons it is visually compelling. That is where these elements are significant.

Within the principles of design and composition one will find the means to make any portrait an expressive, compelling image that will keep the viewer staring at the image long after the surface information has been digested.

CHAPTER FIVE
EXPRESSION

Creating flattering poses and engaging expressions is typically a process that begins before the photography session and continues through the shoot. As your subjects grow more comfortable working with you, and as you continue your consideration of the most flattering way to photograph them, you are building a rapport that will put your subjects more at ease in front of the camera and help you craft the poses and expressions that they are most likely to find appealing.

⊙ PRE-SESSION CONSULTATION

The best way to lay the groundwork for good communication is with a pre-session consultation. Even a short meeting does a lot to put everyone on the same page. The pre-session meeting will also help you to define the client's expectations, both pictorially and financially. It's a good opportunity to outline what the basic session fee covers and what the basic cost of prints is. There should be no misunderstanding about session fees or reprint costs.

⊙ INDIVIDUALITY

Photographer Gary Fagan pays special attention to the differences between people, saying that his philosophy is "to treat each client as a special individual with likes and dislikes of his or her own." He corresponds with them prior to the session to find out their special interests and future plans. He also tries to find out as much as he can about each client so he can "communicate with them to make them

▶ Photographer Jerry D sharpens his portrait skills by making frequent field trips out into places where he doesn't know a soul. He finds interesting people and persuades them to let him make their portrait. In these portraits, he tries to capture the essence of the person, whom he has to surmise quickly. Here, he photographed a beautiful old woman with weathered skin and eyes that tell a million stories. He photographed her close-up with an 85mm f/1.4 lens used wide open to blur the background, which almost looks like a mystical skyscape.

feel at ease." He says, "I suggest the clothing, however they are welcome to bring whatever they wish to make this a more personal session."

⊙ PSYCHOLOGY

Here are a few tips that will improve communication and the quality of your portraits.

- Avoid long periods of silence, even if you need to concentrate on technical details. Reassure the client about any concerns they might have.

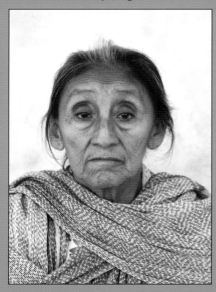

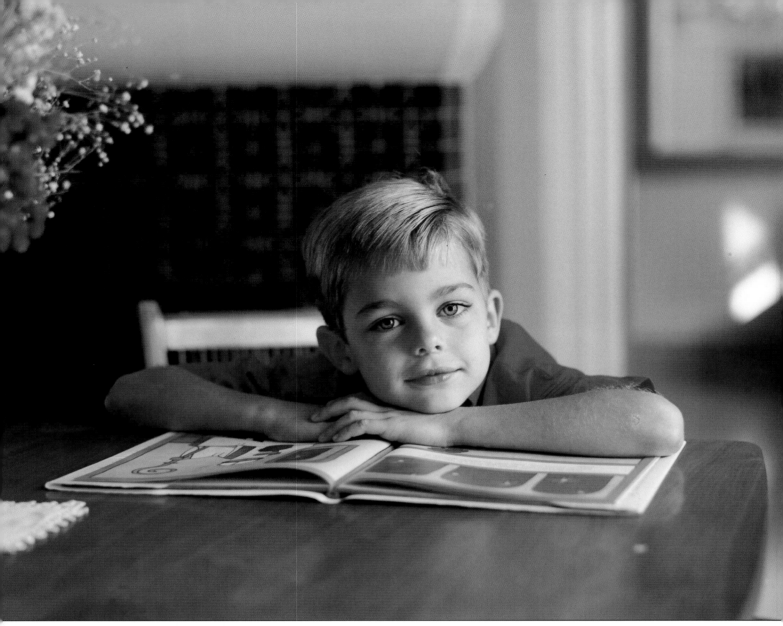

▲ Michael Taylor is great at making an emotional connection with his subjects, young or old. He has a very warm and unassuming personality that makes people feel comfortable and at ease with themselves. Here, his subject was a student in a Pasadena, California elementary school.

- To free the photographer from the burden of the technical details, an assistant is a great idea. He or she can ready the lights and background per the photographer's request and fine-tune the sitting while the photographer and client interact.
- Be positive about the subject's appearance and clothing.
- Work quickly and keep poses fresh and imaginative.
- Be open to suggestions the subject might propose.

- Smile a lot so that your subject can see you are enjoying the session—especially after you make an exposure that you think is a good one. Most people react well to a genuine smile.

● FLATTERING THE SUBJECT
Flattery can be dangerous—too much and it is perceived as insin-cere, and too little and it is seen as indifference or an inhospitable nature. Genuine emotion is best. Expressing your own excitement about getting a good photograph is all it will take to reassure your subject. For instance, saying, "Oh, that was a great one!" after taking an exposure will work, especially if you're sincere. Keep in mind that the actual portrait session is a big

part of the whole portrait experience, and that the underlying goal of most portraits is to make the clients happy about themselves.

● SUBJECT COMFORT

A subject who is uncomfortable will most likely look uncomfortable in the photos. After all, these are normal people, not models who make their living posing professionally. Pose your subject naturally, in a pose that feels appropriate to the subject. If the person is to look natural and relaxed, then the pose must be not only natural to them, but also typical; something they do all the time. Refinements are your job—the turn of a wrist, weight on the back foot, the angle of the body away from the camera, a lean at the waist—but the pose itself should be representative of the person posing.

● EXPRESSION

There is no doubt that the subject's expression is the main ingredient in a successful portrait. Of course, this doesn't just mean capturing a winning smile. The portrait itself, in its entirety, is an expression and hopefully one that reflects much more than surface characteristics. It can be an expression of character—moral and intellectual—at its highest levels, and it has been perceived as such over the centuries. This ability to convey so

▶ While it pays to have a great sense of timing and good instincts as a portrait photographer it also doesn't hurt to be good with people. Becker is one of those people other people instantly like, and his sense of humor precedes him on every job.

many intangible aspects of a person has been what makes portraiture fascinating to people, and it is also what has elevated portraiture to the status of an art form. The portrait, in its most elevated state, is a work of art that is meant to be contemplated with all the powers of the viewer's imagination.

Smile or Serious? Most photographers agree that a pleasant, happy expression is considered more desirable than a big smile. In such a mode, the face is relaxed and people look like themselves. Beware of the "fake smile," as it might show up in anticipation of what they think you want to see. A real smile is quite different than a fake one because it involves the entire face. A fake smile involves just the mouth.

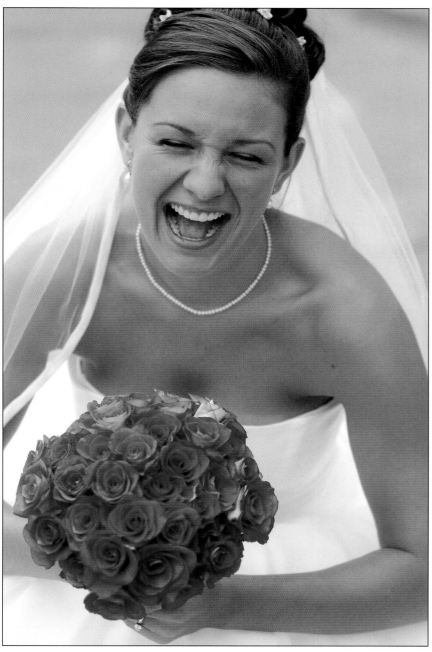

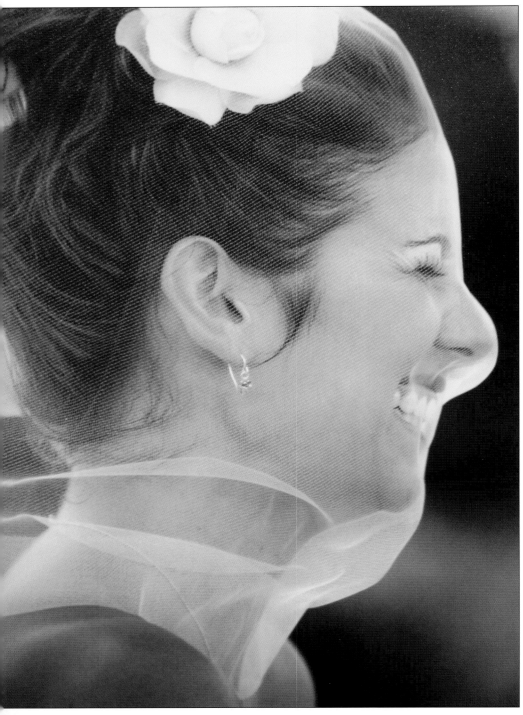

◄ A beautiful profile portrait turned silly when the wind blew the bride's veil into a form-fitting head stocking. The expression was captured as a result of superb observation and timing. Brook Todd was shooting off to the side with a 35—350mm lens when the wind came up creating this fun-filled moment.

phers, Monte believes the smile is the most endearing expression a human being can make, but he recognizes that many people don't look good smiling. In these situations he'll request a more contemplative, serious expression or ask for "a slight suggestion of a smile, not a complete smile"—especially if it appears to be forced. As most portrait photographers will agree, there is nothing worse than an artificial smile. Some patrons, of course, will have a preference and may want to be photographed in a serious pose.

Smiling Eyes. Monte Zucker uses a formula for eliciting a winning smile. He always forces his subjects to show him the whole row of upper teeth when they're smiling. "Anything less than that usually looks artificial." And he will often say, "Smile with your eyes," which gets them to forget about their mouths for the most natural expression.

Bill McIntosh also subscribes to the "smiling eyes" regime and often invokes the smile with a barrage of outrageous flattery or cornball humor. Since Bill photographs so many wealthy women as clients, and he is from the South, it is important that his female clients look "charming." Therefore, McIntosh weaves a web of interaction through conversation and good

The very best way to get the sitter to elicit the smile or look you want is to have earned their trust and for them to be relaxed. If you have had a pre-session consultation, the barriers of a first meeting are already done with, and your subject will be less self-conscious.

Above all, encourage people to be themselves. Create a variety of smiling and non-smiling poses. Most people appreciate the variety.

Eliciting Expressions. Monte Zucker believes that the expression is "the most lasting part of every portrait." Like many photogra-

rapport and tries to establish a rhythm and flow so he can record the subject reacting to their give-and-take conversation.

He says, "When you photograph someone, you are, with your voice and body language, putting your subject in a light state of hyp-nosis. You make exposures surreptitiously and do your best to take their mind off the fact that they are being photographed."

▼ Monte Zucker is the master of the moment, and in this image he really had the little boy thinking. Notice how alive the eyes are and the finger raised as if he is saying, "I have an idea!" or "I get it!" This is the type of pose that could only be created by great interaction between the photographer and the subject.

CHAPTER SIX
POSING STRATEGIES

While the qualities that are typical of a flattering pose and engaging expression may not vary much from image to image, the strategies that photographers use to create them are often quite distinct. Several of these strategies are discussed below.

◉ OBSERVING THE SUBJECT

Tim Kelly is one of America's premiere portrait artists. He has been recognized by all of the professional organizations in North America as one of the finest photographers alive today.

Regarding the process, he has observed that as you turn your attention to load film, you may glimpse your subject in a totally self-disclosing moment. This fleeting and elusive moment became known around Kelly's studio as "the thirteenth frame"—the one that basically got away (referring to the twelve exposures, more or less, afforded by the Hasselblad film magazines). He now pays special attention to the moments during and after breaks in the shooting session.

To his students, he advises, "Watch your subjects before you capture the image. Sometimes the things they do naturally become great artistic poses." Tim Kelly doesn't direct the subject into a pose. Rather, he suggests that you get the subject "into the zone" of the pose by coaching their position, but let them go from there. This allows him to capture a more natural and spontaneous feeling. In fact, Kelly calls his unique style of portraiture "the captured moment," an almost photojournalistic slant to posed portraiture.

This, of course, is a huge departure from the portrait photographer who controls every nuance of the pose from beginning to end. It is not unlike the difference between the traditional wedding photographer, who poses 90 percent of the wedding images in customary fashion, and the wedding photojournalist, who relies on fast lenses, film, and reflexes to capture the emotion of the wedding day.

◉ PROMPTED POSING

Photographer Jerry Ghionis says, "When I photograph weddings, I believe in making my couples look glamorous but natural at the same time. A consistent comment we hear from our clients is that our photos look too good to be true— too glamorous to be unposed but too natural to be posed. I don't pose my clients. I prompt them. I prompt them into situations that appear natural. I will first choose my lighting, then select my background and foreground. I then prompt and direct my clients in a rough situation (a romantic hug, a casual walk, the bride adjusting her veil, etc.). The spontaneous moments I always seem to get are directed and evolve during the shoot depending on what suits the different personalities I am working with.

"I have what I call the 'Wouldn't it be great?' principle. Whenever I say to myself, 'Wouldn't it be great if the bride cracked up laughing, with her eyes

► This is a good example of Tim Kelly's captured moment method of portraiture. The print is called *The Satin Knickers Were a Big Hit!* It's a funny title and an even more humorous print. Kelly believes in capturing his portrait subjects in a natural moment. The pose is very sweet, the expression is very evocative, and the coordination of earth tones is magnificent.

closed, and the groom leaning toward her,' I will ask for it. Some would argue that the shot has been manufactured. I would say no more manufactured than a scene in a movie. Who cares how you got there? The end justifies the means."

A bride is not going to judge a photograph on how perfectly her fingers are placed, nor how perfect the lighting or the background is. She will judge the photograph on how good she looks. If you can get the lighting and composition right and make a bride look glamorous then freeze a spontaneous moment at the same time, you will have an image that sells.

● ACTIVE POSING
One of the recent trends in portraiture is what is called active posing, which is a sort of stop-action glamour posing—isolating the pose from within a flowing movement. This type of posing is useful in photographing trained models, but can also be fun to use with younger subjects, who can be coaxed into moving quite well in front of the camera. Playing music often helps to set the mood, as does keeping the energy level of the portrait session high.

◄ Jerry Ghionis has very definite opinions about how he gets his remarkable poses. "I don't pose my clients. I prompt them. I prompt them into situations that appear natural. I will first choose my lighting, then select my background and foreground. I then prompt and direct my clients in a rough situation (a romantic hug, a casual walk, the bride adjusting her veil, etc.)."

► Brian King created this four-image panel of a young subject, who was obviously enjoying herself immensely. Brian used music and positive reinforcement to coax these great expressions from his subject.

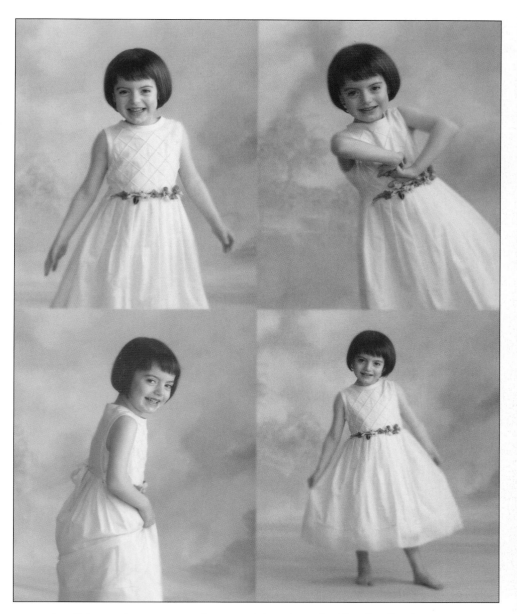

● DEMONSTRATING THE POSE

Showing the subject the pose as you are describing it is a very effective means of communicating with your subjects, as it breaks down barriers of self-consciousness on both sides of the camera. Your natural sense of humor will kick in, particularly if trying to demonstrate a pose to the opposite sex. Your vulnerability and willingness to try different poses is a great icebreaker. As subjects see you do it, it becomes less difficult for them to envision.

● POSING STRATEGY:
JENNIFER GEORGE WALKER

Jennifer George Walker is an up-and-coming portrait artist in the Southern California area. From San Diego, she has carved out a profitable and select clientele by doing what comes naturally, creating art. Although new to print competition, she is quickly gaining a national reputation for her innovative and heartfelt style.

One of her strongest skills is her posing ability. With the help of her assistant, Heather Vallentyne, Jennifer put together the following synopsis of the posing strategy she has developed:

"When I'm photographing a client for the first time, the foremost thing I concentrate on is making them feel comfortable. I focus on the person that I am to photograph. A simple, welcoming, and excited attitude when they arrive at my home studio actually makes a difference in the finished image.

"My excitement is apparent from the moment I open the door and let them inside. I talk about how wonderful it is to have them here. I talk about the artistic goal that we will accomplish together as a team. I show them samples of my previous work, and tell them that with their help, we can create amazing art together. I always begin shooting by briefly describing my lighting setup, the best place to stand, and where the best light is coming from. This allows the subject to know how and where to move.

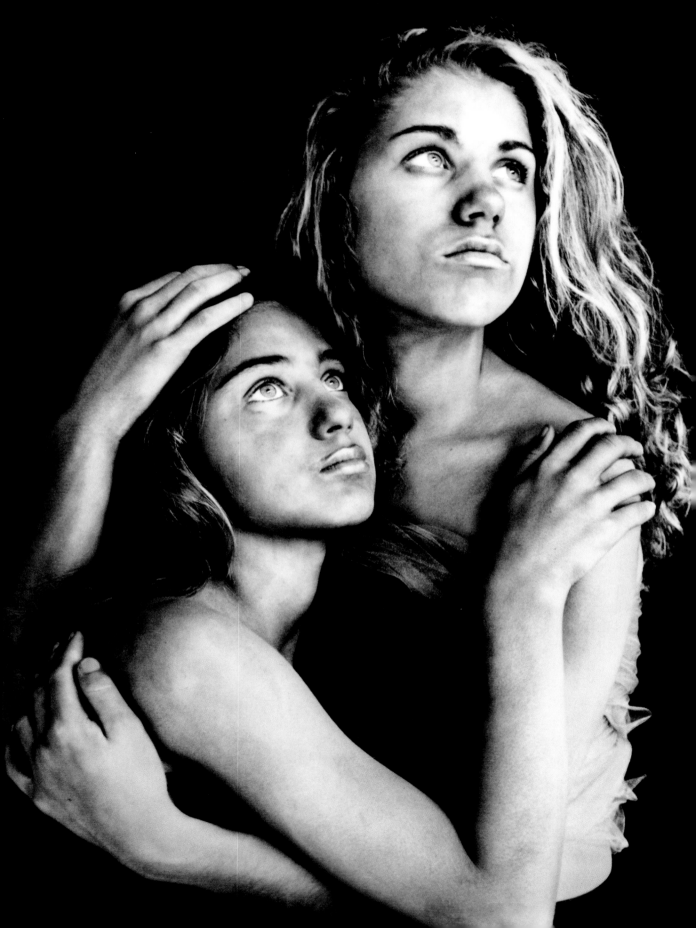

◄ The title of this enigmatic image by Jennifer George Walker is *Embracing Hope*. Jennifer is both an artist and a portrait photographer whose artwork is done for paying clients. She says of her work, "I push myself creatively in order to offer things to my clients that they have never seen before." Such is the stuff of this image, with its dramatic posing and lighting, and the subjects in a global embrace. This image is from a body of work in which Jennifer has experimented with changing the skin color of people. She says, "I am enthralled with the idea that who we are is much more than skin deep, and it doesn't matter what color you are on the outside, it is the soul underneath that is so beautiful. I had been playing with body paints—those used in the theater, and found this powder called Texas Dirt. It comes in all shades and it gave me the idea to 'color' a subject to have different color than their original skin tone."

"I have found that the two most important elements to a successful session are to first, direct the subject, and second, to quietly encourage the look and attitude that I want. When I direct the subject I will physically show them where and how to pose. I role-play as the model and have them copy the movements. Once I walk behind the camera, I refine the pose, telling them where to place their hands, etc. I do .this quickly but with a calm and quiet voice.

"Then to evoke the emotion I am looking for, I tell them who they are portraying or what emotion they are portraying. With a quiet and calm voice, I am able to elicit the certain emotion that I am looking for and produce an artistic expression.

"Here is a quote from a fellow photographer who has seen me work: 'I see you elicit emotion from your subjects by connecting with them verbally and with your eyes. You talk very softly to them and ask them to bring up emotions that you are trying to depict in the photo. You keep working with them until they get into their feelings and those feelings come through in their expressions, especially their eyes. You usually like to have music that goes along with the emotions you are going for playing softly in the background. You start with an idea of what you want to see emotionally in your subjects and focus on that with them. You also paint a mental picture for them of what you are trying to achieve. You ask them to use their eyes to tell the story.'"

● **POSING STRATEGY:**
TERRY DEGLAU
Terry Deglau is an accomplished portrait photographer with a long and varied career. He has devised a posing strategy that combines the mind-set of the fashion photographer with the precision of the portrait photographer. Traditionally, according to Terry, the posing sequence follows this order:

1. Pose the subject.
2. Set the lights.
3. Make some exposure readings.
4. Stand back and survey the subject, make some minor clothing adjustments.
5. Move the camera, and check the focus.
6. Call for the expression, and finally make the exposure.

Consider, alternatively, the fashion photographer's sequence. It's the same series of events, just a different order:

1. Stand back and survey the subject, make some minor clothing adjustments in the dressing room.
2. Set the lights.
3. Make some exposure readings.
4. Move the camera, and set the focus area for the model to work in.
5. Show the model where their pose will be photographed. Move and turn into the light.
6. Call for the expression, and finally make the exposure.

Here is Terry Deglau's posing strategy, which he says is somewhere in the middle, between the studio portrait photographer and the fashion photographer:

1. Put the subject in position, and build the pose.
 a. Subject stands tall, firmly on two feet, facing you.
 b. Move weight onto back foot, position front foot, bend knee for feeling of movement.
 c. Rotate hips for flow of pose.
 d. Turn shoulders, back shoulder lower than front shoulder.
 e. Lean the body.
 f. Position hands.
 g. Turn and tilt head.
2. Place the lights.
3. Place camera and crop for area to photograph.
4. Final exposure check.

5. Start photographing. Talk to your subject. Start at the beginning position, then say, "Turn this way, weight on your left foot, point the right foot to me, bend your knee, etc." Or, "Lean into the rock, head tilt, turn your head this way!" Use your hands to help direct head tilt and turns.

6. Call for the expression—remember, your smile tells them how much of a smile you want back from them!

7. Make four or five exposures using this same procedure.

8. After you're sure you have this one, change the pose or the camera position. Try a three-quarter-length pose or a head-and-shoulders pose. Adjust the lighting, location, and clothing.

▶ This is an example of Terry Deglau's unique posing strategy. A canyon is a deep hole in the afternoon. The skylight is high and dark blue, giving the scene a straight-down direction of cool blue light. This is not the best light for a portrait. Terry used a DP320 Allure Norman Light with a 22-inch soft box on the highlight side of the subject to wipe out the overhead light. The DP320 has full, half-power, and quarter-power settings. For this image, a one-quarter-power setting was used with a 4-inch magenta warming gel added to give warmth to the flash. You can still see the reflection of the blue sky in the highlights of the black leather slacks. Terry used the above-described posing strategy to create this gorgeous portrait.

POSING GROUPS

Posing groups, both small and large, is more a question of design and technical problem solving than it is a pure posing exercise. There are a number of ways to look at designing groups.

The first consideration is technical. You should design a group so that those posed in the back are as close as possible to those in the front. This ensures that your plane of focus will cover the front row as well as the back row, thus making it easy to hold the focus, front to back.

The second consideration in designing groups is aesthetic. You are building a design when creating a group portrait. Norman Phillips likens group portrait design to a florist arranging flowers. He says, "Sometimes you want a tight bouquet of faces. Other times you might want to arrange your subjects so that the group looks interesting apart from the dynamics of the people in the group." In other words, sometimes the design itself is what's important.

A third consideration is proximity. How close do you want

◄ The posing is exemplary in this beautiful portrait of sisters by Larry Peters. The smaller sister joins the seated older sister to form a beautiful triangle shape, unifying the composition. Notice how the older sister's hands are posed—showing only the edges and demonstrating a nice break to the wrist. The background is softened and each face was expertly worked to give the girls an angelic glow.

each member of the group to be? Phillips relates proximity to warmth and distance to elegance. If you open the group up you have a lot more freedom to introduce flowing lines and shapes within the composition of the group. A tightly arranged group, where members are touching, implies warmth and closeness.

● POSING HIERARCHY
Should you pose by age, importance, or size? This is a question of considerable debate among group portrait photographers.

Some say to concentrate on organizing the groups and subgroups of a family logically. Some feel that the family is more cohesively arranged if organized by age (grandparents in the middle, with their children adjacent and the grandchildren and their families in the outer realms of the group). In either case, one can then arrange the individual subjects by size within each subgroup for the most pleasing composition.

Many photographers feel that posing by size and shape creates

▶ While head height is nearly identical in this wedding party, the photographer cleverly introduced a diagonal line by tilting the camera slightly and choosing a lower-than-normal viewpoint. The focus was, naturally, on the bride, and the result is a dynamic group portrait of the bride and her bridesmaids. Image by Michele Celentano.

▶ **(BOTTOM)** Breaking the rules can be fun, particularly when you know exactly what you are doing. Joe Buissink photographed these two beautiful faces side by side. Why would an image so symmetrical be so fascinating? Maybe it is fascinating *because* of its symmetry.

the most interesting and attractively posed group. This is certainly true for weddings where groups, formal or informal, can be arranged in any number of ways, as long as the bride and groom are centermost. This method also affords the photographer the most flexibility to flatter the individual members of the group.

● HEAD LEVELS AND PLACEMENT IN GROUPS

No two heads should ever be on the same level when next to each other, or directly on top of each other. As a rule, this is only done in team photos. Not only should heads be on different levels, but subjects should be as well. In a group of five people you can have all five on a different level—for example: one seated, one standing to the left or right, one seated on the arm of the chair, one kneeling on the other side of the chair, one kneeling down in front with their weight on their calves. Always think in terms of multiple levels. This makes any group portrait more pleasing.

Regarding proximity of one head to another, be consistent. Don't have two heads close together and two far apart. There should be a more or less equal distance between each of the heads. If you have a situation where one person is seated, one standing, and a third seated on the arm of the chair (placing the heads of the two seated subjects in close proximity), then back up and make the portrait a full-length. This minimizes the effect of the standing subject's head being so far from the others.

● THE POSING DIALOGUE

It's better to show than to tell your subjects how you want them to pose. Act out how you want each person to pose. It's much easier than describing what you want and it takes less time. Once they are in the pose you want, wait for the special moment when they forget all about having their pictures taken. Then it's showtime.

Be positive and always be in charge. Once you lose control of a large group it's difficult or impossible to regain it.

Talk to your subjects and tell them how good they look and that you can feel their special emotion (or whatever comment seems most appropriate). Let them know that you appreciate them as unique individuals, and so on. If closeness is what you are after, talk them into it. It sounds hokey, but if it does nothing more than relax your subjects, you have done a good thing.

● SMALL GROUPS

Couples. The simplest of groups is two people. Whether the group is a bride and groom, a brother and sister, or grandma and grandpa, the basic building blocks call for one person to be slightly higher than the other. Generally speaking, the mouth height of the lower subject should be at the forehead height of the higher subject. Many photographers recommend "mouth to eyes" as the ideal starting point.

Although the two subjects can be posed parallel to each other—each with their shoulders and heads turned the same direction (as one might do with twins, for example)—a more interesting dynamic can be achieved by having the pair pose at 45-degree angles to each other, so their shoulders face in toward one another. With this pose you can create a number of variations by moving them closer or farther apart. Another intimate pose for two is to have two profiles fac-

▲ Joe Buissink created this portrait of the bride and groom dancing. The composition is perfect, as is the intimate pose—a kiss within the dance. Note that the couple no longer "reads" as two individuals, but as one entity.

► Joe Photo created this dynamic engagement portrait. The couple, in the midst of a huge canyon, was photographed on horseback. You can see the light coming from either side of the canyon (note the highlights on either side of the groom's forehead). Color correction was important, but the image was made by available light with a Nikon D1X, 80–200mm lens at 170mm, at an exposure of 1/400 at f/2.8.

ing each other. One should still be higher than the other, to allow you to create an implied diagonal line between their eyes, giving the portrait direction. Also, since this type of image will be fairly close up, you will want to make sure that the frontal planes of their faces are roughly parallel so that you can hold the focus on both faces.

Using an armchair allows you to seat one person, usually the man, and position the other person close and on the arm of the chair, leaning on the far armrest. This puts their faces in close proximity but at different heights. A variation of this is to have the woman seated and the man standing. However, when their heads are so far apart, you should pull back and make it a full-length portrait. Also, when you seat the woman in an armchair, her hands should be in her lap, thus slimming the waist, thighs, and hips. She should be seated at an angle, and the leg farthest from the camera should have the foot "hooked" behind the front leg—a pose which women seem to fall into naturally.

For as many examples as are given here, there are ten times as many variations that you can consider. As you study groups of two in the work of other photographers (there are many good examples in this book), you'll see that there are some very dynamic ways to pose two people.

Adding a Third Person. A group portrait of three individuals is still small and intimate. It lends itself well to either a pyramid- or diamond-shaped composition, or to an inverted triangle, all of which are pleasing to the eye. Don't simply adjust the height of the faces so that each is at a different level. Use the turn of the shoulders of those at either end of the group as

◄ Stephen Pugh captured this delightful twosome at a wedding reception. One subject in front of another is a great way to picture two people. The bars of the chair back create an interesting repeating pattern for the eye to follow.
▼ Jerry Ghionis created this unusually beautiful portrait, incorporating the long diagonal of the sports car by photographing the scene from above. A small triangle of the white lines in the parking lot is seen above their heads, providing a border that contains and balances the long diagonal line of the car. The pose and intimate expressions are as natural as if the photographer weren't even there.

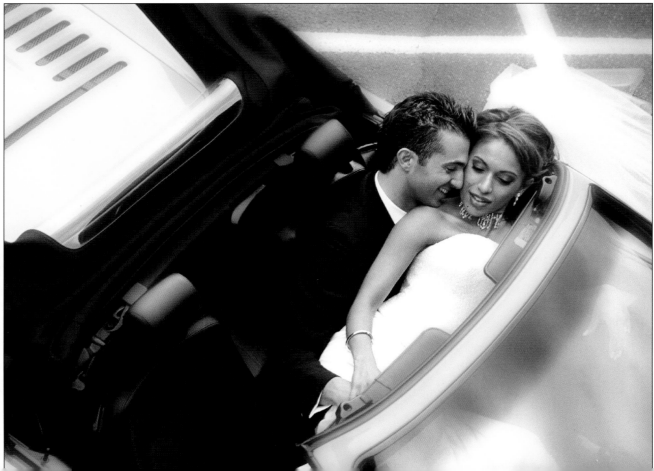

▲ Jennifer George Walker created this beautiful portrait called *Little Sisters* by intertwining the girls so that their faces formed a triangle shape. As a viewer, you cannot help but go from one face to the next in succession. The overall composition is a pyramid shape, which adds a second major triangle shape. The expressions are beautiful and each is different, reflecting three different personalities.

a means of looping the group together.

Once you add a third person, you will begin to notice the interplay of lines and shapes inherent in good group design. As a visual exercise, plot the implied line that goes through the shoulders or faces of the three people in the group. If the line is sharp or jagged, try adjusting the composition so that the line is more flow-ing, with gentler edges. Try a simple maneuver like turning the last or lowest person in the group inward toward the group and see what effect it has.

Try different configurations. For example, create a single diagonal line with the faces at different heights and all people in the group touching. It's a simple yet very pleasing design. The power and serenity of a well-defined diagonal line in a composition can compel the viewer to keep staring at the portrait long after the visual information has been interpreted. Adjust the group again by having those at the ends of the diagonal tilt their heads slightly in toward the center person. It's a slight adjustment that can make all the difference.

How about trying the bird's-eye view? Cluster the group of three together, grab a stepladder or other high vantage point and you've got a lovely variation on the three-person group.

When you add a third person to the group, the sheer number of hands and legs starts to become a problem. One solution is to show only one arm and leg per person. This is sage advice, especially when the members of the group are similarly dressed. When too many hands are showing, it's not always clear which hand belongs to which person. Generally, the outer hand (that closest to the camera) should be visible, the inner hand, compositionally, can be easily hidden.

Groups of three and more allow the photographer to draw on

more of the available elements of design, in addition to the design elements of the group itself. The accomplished group photographer will incorporate architectural components, or natural elements like hills, trees, shrubs, flowers, gates, archways, furniture, etc.

As you add more people to a group, remember to do everything you can to keep the film plane parallel to the plane of the group to ensure everyone in the photograph is sharply focused. Focusing is covered in greater detail at the end of this chapter.

Adding a Fourth. This is when things get interesting. As you photograph more group portraits, you'll find that even-numbered groups of people are harder to pose than odd-numbered groups. Three, five, seven, or nine people are much easier to pose than simi-

◀ (TOP) Mercury Megaloudis created this charming image using a wide-angle lens from a vantage point above the girls. The lens forces the two little girls into the foreground and the picket fence creates a frame-long diagonal line.

◀ (BOTTOM) In a group of three, often the two outer members bracket the central member of the group. That is what Fran Reisner did here, but with the additional balancing element of the bicycle in the background, which creates visual tension in the portrait. The final image was treated in Painter.

▼ This lovely family portrait was made by Clay Blackmore. The beautiful triangle shape of the portrait makes the viewer's eye travel from one face to the next. The available light was augmented by fill flash.

larly sized even-numbered groups. The reason is that the eye and brain tend to accept the disorder of odd-numbered objects more readily than even-numbered objects.

With four people, you can simply add a person to the existing poses of three described above—with the following caveat: Be sure to keep the eye height of the fourth person different from any of the others in the group. Also, be aware that you are now forming shapes within your composition. Think in terms of pyramids, inverted triangles, diamonds, and curved lines. Note that the lines created by various body parts (for instance the line up one arm, through the shoulders of several people, and down the arm of the person on the far side of the group) form implied lines that are just as important as the shapes you define with faces.

An excellent pose for four people is the sweeping curve of three people with the fourth person added below and between the first and second person in the group.

The fourth person, if not dressed the same as the others (this happens often) can also be positioned slightly outside the group for accent, without necessarily disrupting the color harmony of the rest of the group.

When two of the four are little people, they can be "draped" to either side of the adults to form one of the pleasing triangle shapes. For example, if children are positioned close to the adults but still on the outside of the group, they can lean in close to the adult so that their shapes are seemingly a part of the larger composition.

▲ Marcus Bell decided to "pose" this group having fun, dancing, and carrying on. A sense of timing and a great directorial spirit made this image memorable. Due to the "closed" stance of the right- and left-hand men, the eye stays contained within the free-form composition.

Five and More. Remember that the composition will always look better if the base is wider than the top, so the fifth person should be positioned to elongate the bottom of the group.

Remember too that each implied line and shape in the photograph should be designed by you and should be intentional. If it isn't logical (i.e., the line or shape does not make sense visually), then move people around and start again. The viewer's eye should not just meander through the image, but it should be guided by the lines and shapes you create within the composition.

Try to coax S shapes and Z shapes out of your compositions.

◄ Jennifer George Walker is a superb group photographer. In this image, called *Creating Harmony*, she combined totally dissimilar children, all dressed the same, in a beautifully harmonious portrait. The fourth person added is usually an adjunct to the existing composition, adding to the length of the primary shape, in this case, a subtle triangle. Notice that the eye height is different throughout, creating visual interest and a hopscotch effect for the viewer.

◄ (BOTTOM) This beautiful family portrait follows the line of the sand dune. All of the family members are beautifully color-coordinated and the image was watercolored in Corel Painter. The simplest of activities can engross your subjects. Photograph by Elizabeth Homan.

lines and using the increased space to slot extra people.

● BIG GROUPS

Once a group exceeds nine people, it is no longer a small group. The complexities of posing and lighting are expanded, and if you don't stay in control, chaos will reign. It is always best to have a game plan in mind with big groups.

Posing bigger groups requires you to use standing poses, often combined with sitting and kneeling poses. Those standing should be turned to at least a 20-degree angle to the camera so that their shoulders are not parallel to the film plane. The exception is with small children who gain visual prominence when their shoulders are square to the camera.

With standing poses, care must be taken to disguise wide hips and torsos, sometimes by using other people in the group. Always have each subject create a space

They form the most pleasing shapes and will help to hold a viewer's eye within the borders of the print. Also, remember that the diagonal line has great visual power in an image and is one of the most potent design tools at a photographer's disposal.

The use of different levels creates a sense of visual interest and lets the viewer's eye "ping-pong" from one face to another (as long as there is a logical and pleasing flow to the arrangement). The placement of faces, not bodies, dictates how pleasing and effective a composition will be.

When adding a sixth or an eighth person to the group, the group still must look asymmetrical for best effect. This is best accomplished by elongating sweeping

between their arms and torsos by placing a hand on a hip or, in the case of men, placing a hand in a pocket (thumb out).

In really large groups, clothing coordination can be a nightmare. It is often best to divide the group into subgroups—family units, for instance—and have them coordinate with each other. For example, a family in khaki pants and yellow sweaters could be placed next to a family in jeans and red sweaters.

It is important that the poses you put your subjects in are natural and comfortable. Even experienced group photographers working with assistants will take ten minutes or so to set up a group of twenty or more. This makes it especially important that your subjects be posed comfortably. Natural poses, ones that your subjects might fall into without prompting, are best and can be held indefinitely.

It is important that the group remains alert and in tune with what you are doing. Here is where it is important to stay in charge of the posing. The loudest voice—the one that people are listening to—should be yours, although by no means should you be yelling at your group. Instead, be assertive and positive and act in control.

With natural poses, have your antennae up for errant thumbs and hands. Do a perimeter check, dissecting the group along the vertical and horizontal axes, to make sure there is nothing unexpected in the posing.

▶ (TOP) Ken Sklute is a master at photographing large-size groups. Here, he arranged a central triangle shape including the bride between two diagonal sweeping lines so that your eye is always forced upward toward her. He used flash fill from the side to yield a good facial modeling to the light. The scene was photographed near midday, possibly the worst time of day to try to make such an image.

▶ (BOTTOM) This portrait was made by Michael Taylor as part of a gang education program in Los Angeles elementary schools. The grouping is loose, and the kids who are not facing the camera are not looking at it either—a trick for making them less dominant in the image. Note the use of overlapping triangular shapes in the composition.

● LINKING SHAPES

When working with groups of six or more, you should start to base the shapes within the composition on linked shapes, like linked circles or triangles. For example, a group of seven could be posed as two interlocking diamonds (side-by-side), with the person at the center of the frame being a member of both diamonds, thus linking them. What makes combined shapes like these work is to turn them toward the center—the diamond shape on the left can be turned 20 degrees or less toward center, while the diamond shape on the right can also be turned toward the center.

● POSING HANDS IN GROUP PORTRAITS

Hands can be a problem in group portraits. Despite their small size, they attract attention to themselves, particularly against dark clothing. They can be especially problematic in seated groups, where at first glance you might think there are more hands than there should be.

A general rule of thumb is to either show all of the hand or none of it. Don't allow a thumb or half a hand or a few fingers to show. Hide as many hands as you can behind flowers, hats, or other people. Be aware of these potentially distracting elements, and look for them as part of your visual inspection of the frame before you make the exposure. One trick for men is to have them put their hands in their pockets, leaving the cuff showing, if there is one. A variation is for them to "hitch" their thumb outside the pocket, which forms a nice triangle shape in the bent arm and makes it apparent to the viewer that the hand is in a pocket. For women, try to hide their hands in

◄ Capturing large groups, such as this entire wedding ensemble, often involves some compromises. The only way Dennis Orchard could capture the entire group and the surrounding ambience was to use a series of flash units and a very wide-angle lens, almost a fisheye. The walls distort and the unfortunate patrons near the frame edges also distort, yet he gets the entire group in, with the bride centrally positioned so she would not distort.

◄ Here's how to make a large group behave like a smaller group. Michael Taylor actually created four distinct groups, linking the center two groups by proximity, to create a well-balanced, color coordinated family portrait. The portrait was made in the late afternoon with almost imperceptible flash from the camera position. The warm glow of the backlighting acted like a hair light to provide a glow around each child.

▲ In this diagram you can see how certain persons within the group are common to one or more groups. For instance, here, two diamond shaped groups rely on the central person to "link" the two groups together, thus creating a single unified group within the composition. Diagram by Shell Dominica Nigro.

► **(TOP)** Frank Frost created this portrait using dynamic composition (there are two linked triangle shapes within the composition) and elegant lighting. The beautiful color coordination and expressions make this portrait memorable.

► **(BOTTOM)** In this beautiful group portrait made by Frank Frost, at least one hand from each person is accounted for and placed logically. Hands placed in pockets should be hitched with the thumb out so you can see the hand and not a stump. Other hands should be hidden from view to simplify the pose.

their laps or by using other people in the group.

The smaller the group, the more likely you will need to pose the hands. In these situations, keep in mind the rules: never photograph a subject's hands pointing straight into the camera lens (this distorts the size and shape of the hands), and always have the hands at an angle to the lens.

● COORDINATING APPAREL

Sometimes the group composition will be dictated by what the people are wearing. Bill McIntosh is a master of the coordinated environment. Here's what he has to say

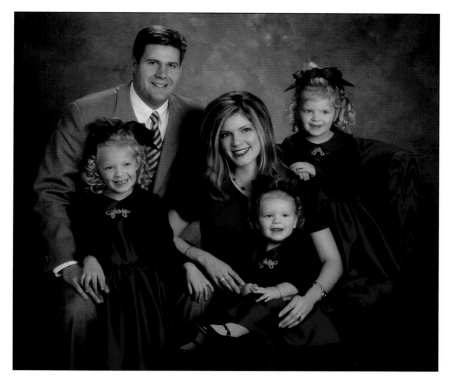

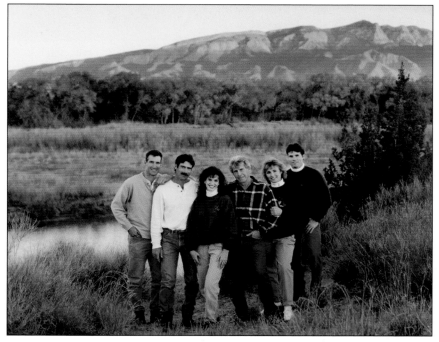

about planning: "No matter how good your artistic and photographic skills are, there is one more element required to make a great portrait: color harmony."

In McIntosh's portraits the style and color of the clothing all coordinate. He says, "I have en-

sured these suit both the subjects and the environment chosen." Bill makes sure everything matches. "Time is well spent before the sitting discussing the style of clothing—formal or casual—and then advising clients of particular colors that they feel happy with and

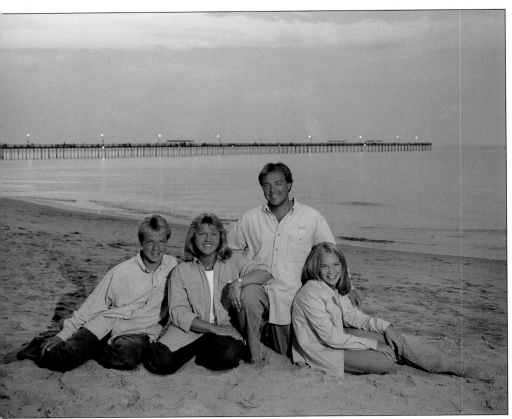

▲ Bill McIntosh is a wizard at coordinating his family groups. He will usually conduct a meeting with the family where they decide on the clothes—and he might even ask to see them so that he can mix and match. This image was made at dusk in Virginia Beach, Virginia. Bill fired a flash as a main light and used the "big soft box in the sky" as fill.

which will also create a harmonious portrait," he says.

White is a photographers' favorite, provided the subjects are of average weight or on the slender side. If your group is on the large side, all that white will make their necks and torsos look much larger than they really are. The general rule of thumb is wear white or pastels, gain ten pounds; wear dark or medium shades, lose ten pounds.

Solid-colored clothes, in cool or neutral shades and with long sleeves, always look good. Cool colors like blue and green recede; warm colors like red, orange, and yellow advance. Cool colors or neutrals (like black, white, and gray) will emphasize the faces and make them appear warmer and more pleasing in the photographs.

Your groups' garments should also blend. For example, all of the family-group members should wear informal or formal outfits. It's easy when photographing a wedding party, since everyone is already dressed identically and formally. Half your battle is won. It is difficult to pose a group when some people are wearing suits and ties and others are wearing jeans and polo shirts.

Shoe styles and colors should also blend with the rest of a person's attire. Remember, dark outfits call for dark shoes and socks.

● GROUP EXPRESSIONS

One of the best ways to create natural smiles is to praise your subjects. Tell them how good they look and how much you like a certain feature of theirs. By sincere confidence-building and flattery you will get the group to smile naturally and sincerely, and their eyes will be engaged.

The mouth is nearly as expressive as the eyes. Pay close attention to your subjects' mouths to be sure there is no tension; this will give the portrait an unnatural, posed look. If you spot someone in the group that needs to relax, talk to him or her directly in a calm, positive manner. An air of relaxation best relieves tension, so work to achieve that mood.

● OBVIOUS THINGS TO AVOID

One of the biggest flaws a photographer can make in a group portrait is to include a background element that seems to sprout from one of the subjects.

While this is mostly an amateur mistake, the truth is that many top professionals still make this same mistake from time to time. The problem is that the photographer fails to do a final perimeter check. That's where you scan the group's silhouette, making sure there's nothing in the background that you missed.

Pay particular attention to strong verticals, like light-colored posts or columns, and also diagonals. Even though these elements may be out of focus, if they are tonally dominant they will disrupt and often ruin an otherwise beautiful composition.

One way to control your background more effectively is to scout the locations you want to use before you show up to make the portrait. Check the light at the right time of day and be prepared for what the changing light might do to your background an hour or two later.

● FOCUS

Shifting the Focus Point. After determining depth of field for a given lens at a given focusing distance and taking aperture (by examining the depth-of-field scale on the lens), you can determine the range in which you can capture all of your subjects sharply. For example, at a subject-to-film plane distance of 120 inches (ten feet), an 80mm lens set to f/8 will, hypothetically, produce depth of field stretching from 120–148 inches

▶ Before the session, all good portrait photographers ask their subjects what some of their activities are. Here portrait artist Tammy Loya took it to the next level, directing a family card game full of the usual family hijinks. The result is much like a Rockwell painting. The backlighting creates a nice glow and hair light around each boy.

▶ While there's no doubt who the comedian is in this family—the real question is what role the photographer, Jerry Ghionis, played in the picture's outcome. Sometimes you won't get too many chances with kids, so it pays to have great timing. Here's an insight into Jerry Ghionis' posing philosophy, which may demonstrate how this image evolved. "I consider myself a director who happens to be holding a camera rather than a photographer who happens to direct. I believe in simple but striking images. I believe in not just waiting for the moment, but making the moment."

(10 feet to 12 feet 4 inches), producing an effective depth of field of 28 inches.

The depth of field falls roughly half in front of and half behind the point of focus. In the above example, if you focus on the front row of the group, then at least half of the total depth of field will fall in front of the group, reducing the effective depth of field in the subject area down to about 14 inches. However, by shifting the focus point into the middle of the group (front to back), you can expand the

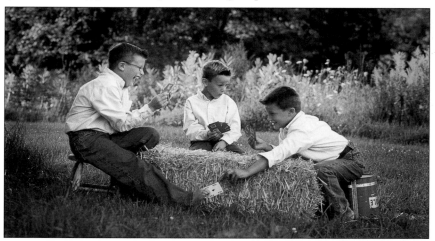

effective depth of field by taking advantage of the full 28 inches (14 inches in front of the focus point, and 14 inches behind it). While your inclination might be to focus on the front row of the group, your most effective focus, at any taking aperture, will be when you shift the focus into the middle of the group.

The significance of the above example is critical for photographing groups because you must modify the poses of each person in the group to accommodate the narrow

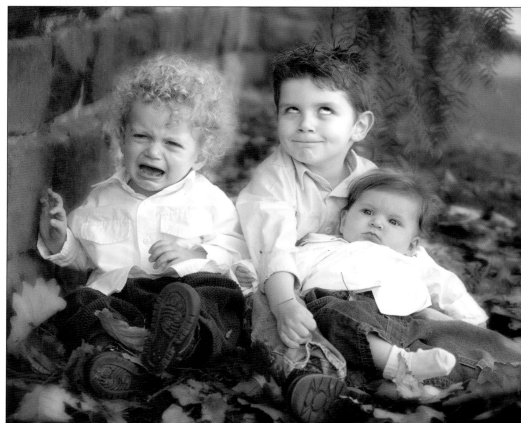

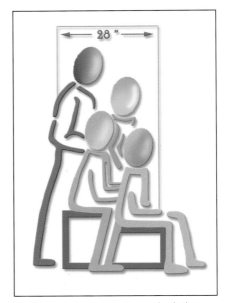

▲ Raising the camera angle helps to realign the plane of the group more closely with the film plane. As you can see from the above example, the hypothetical 28-inch depth of field is more effective in covering the focus of the group when the camera is raised than when the camera is at the eye level of the group. (Diagram concept courtesy of Norman Phillips.)

► By having those in the back of the group lean forward and those in the front of the group lean back, you can effectively shrink the plane of focus to better accommodate your effective depth of field. (Diagram concept courtesy of Norman Phillips, diagrams by Shell Dominica Nigro.)

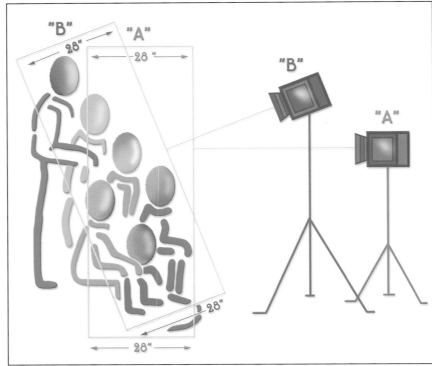

plane of focus; in this example, 28 inches. As seen in the diagram, subjects in the back of the group can lean in and subjects at the front of the group can lean back slightly so that all of your subjects fall within that plane of effective depth of field.

Making the Film Plane Parallel to the Group Plane. Suppose your group is large and you have no more room in which to make the portrait. One solution is to raise the camera height, angling the camera downward so that the film plane is more parallel to the plane of the group. This will not change the amount of depth of field that exists at that shooting distance and lens aperture, it is still only 28 inches (as in the above example), but it will optimize the plane of focus to better accommodate that same 28-inch depth of field.

Don't count on being able to shoot out of a second story window or off of a convenient sunporch. Chances are you won't have access. For this reason, a stepladder is a must for large groups and, in fact, should be a permanent tool in your wedding arsenal for group portraits.

Stepladders give you the high angle that lets you fit lots of people together in a tight group, like a bouquet of flowers. They also let you raise the camera height just slightly so that you can keep the group plane parallel to the film plane for better depth of field control. Ladders also give you a means to correct low shooting angles that distort perspective.

The stepladder is the answer to these situations, but one word of caution: have your assistant or someone strong hold the ladder in case the ground gives or you lean the wrong way. Lawns, especially after watering or a recent rain, will be soft and can allow one leg of your ladder to sink. While watching you come tumbling down might create a priceless group expression, you will, unfortunately, be unable to photograph it.

The tendency is to overuse the stepladder, so use one when you need to or when you want to offer variety in your groups—not for every shot.

CHAPTER EIGHT
STUDIO AND OUTDOOR LIGHTING

The human face consists of a series of planes, none of which are completely flat. The face is sculpted and round. It is the job of a portrait photographer to show the contours and form of the face. This is done primarily with highlights and shadows. Highlights are areas that are illuminated by a light source; shadows are areas that are not. The interplay of highlight and shadow creates roundness and shows form.

Beyond showing three dimensions, lighting and posing go hand in hand, because without a firm grasp of lighting techniques, you cannot refine and perfect your best poses. Further, lighting is an extension of posing, particularly corrective posing, wherein a type of lighting is selected to mask or enhance a specific aspect of the subject's body or face.

● STUDIO LIGHTING
The Key and Fill Lights. The key and fill lights should be high-intensity lights in either reflectors or diffusers, such as parabolic reflectors, umbrellas, or soft boxes.

Pan reflectors (often called parabolic reflectors) are silver-coated "pans" that attach to the light housing and reflect the maximum amount of light outward in a focused manner. Light that emanates from a parabolic reflector is sharp and specular in nature. It produces crisp highlights with a definite line of demarcation at the shadow edge. The highlights that an undiffused light source produces often have miniscule specular

▶ David Bentley created this beautiful high-key portrait on a set with white lace curtains. Soft light is flooded through those curtains toward the set. In this instance, the key light is behind the subject. With the use of a secondary soft box used on the frontal side of the subject, all the shadows are filled in, creating a very high 2:1 lighting ratio. Soft light, used close to the subject, creates beautiful wraparound lighting with almost no shadows. David raised the exposure level toward the highlights to keep the exposure high key. The pose is simple and sweet.

highlights within the overall highlight—a phenomenon often referred to as highlight brilliance. Most photographers don't use parabolic reflectors anymore, opting for diffused key and fill-light sources.

Diffused light sources use small reflectors within the umbrella or soft box to focus the light onto the outermost translucent surfaces of the diffusion device, which can be very large. Bathing the subject in light, these diffused light sources are much simpler to use than undiffused ones. Whether they are called soft boxes, umbrel-

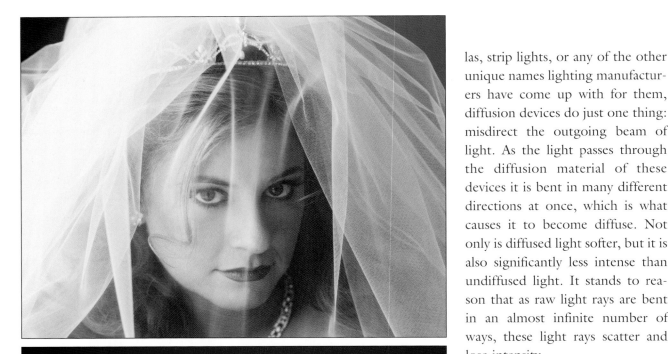

las, strip lights, or any of the other unique names lighting manufacturers have come up with for them, diffusion devices do just one thing: misdirect the outgoing beam of light. As the light passes through the diffusion material of these devices it is bent in many different directions at once, which is what causes it to become diffuse. Not only is diffused light softer, but it is also significantly less intense than undiffused light. It stands to reason that as raw light rays are bent in an almost infinite number of ways, these light rays scatter and lose intensity.

Umbrellas and soft boxes are the ideal lighting solutions for most portraits. A single soft box

◄ (TOP) Between this and the following image you can see the differences between direct and diffused light. This is an example of highly diffused light that wraps around the contoured surfaces of the face. The light source appears to be window light with no distinct fill-in source. This image, by the way, is an example of broad lighting, in which the majority of the face is illuminated by the main light source. Photograph by Fran Reisner.

◄ Anthony Cava created this striking image of a model, whom he had recently photographed for a catalog. Anthony used a parabolic light source off to the right to light her body. He then used a light with grid (to narrow the beam of light) to light her face. The parabolic reflector and grid light produce a much harder light than soft boxes or window light. You can see that by examining the hard shadows on both the background and the distinct shadow on her neck that mirrors the lighting pattern. Direct light not only produces distinct shadows, but it creates levels of highlights on contoured surfaces. Note the highlight brilliance on the bridge of the subject's nose and forehead.

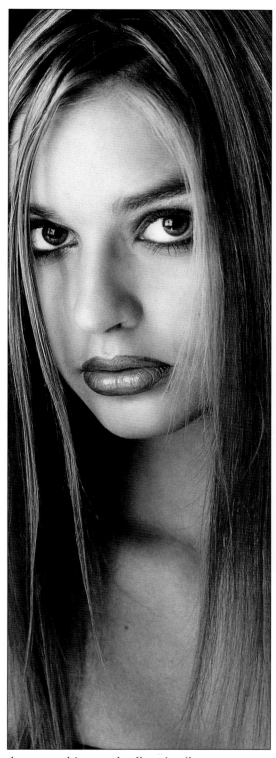

▲ Brian King of Cubberly Studios in Ohio loves soft light. He will either use a huge bank of strobes in a 7-foot soft box or he will use the studio's three bay windows as a huge wraparound soft box. In this senior image, he further diffused the contrast of the soft light and softened all but the mask of the senior's face using Photoshop. Whenever the window light is used as the main light source, a large reflector is positioned close to the face.
▶ Bambi Cantrell created this unusually cropped portrait that accentuated the long lines of the model's hair and neckline. She used a very large soft box very close to the model and a reflector just to camera right. If you look closely, you can see in the model's eyes the catchlights that reflect the light sources.

will produce beautiful soft-edged light, which is quite forgiving and features large elegant highlights, a low lighting ratio, and beautiful wraparound light. To get the maximum effect from a soft box or umbrella, the light should be positioned close to the subject. The farther away it is, the less diffused it will be.

Umbrellas differ in terms of their interior tones. A silver- or gold-foil-lined umbrella produces a more specular, direct light than does a white umbrella. A silver umbrella will also produce detailed specular highlights in the highlight areas of the face. Some umbrellas, often called zebras, come with intermittent white and silver pan-

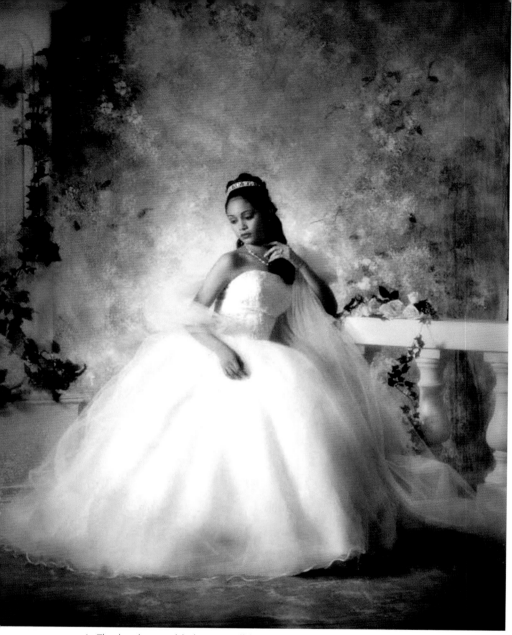

▲ The background light, a small light positioned between the model and the background, is used to provide separation between the background and the subject and also to create the feeling of depth in a portrait. The hair light is used to add subtle highlights in the hair, which also provide dimension. Photograph by Robert Lino.

els. These produce good, overall soft light with specular highlights.

Umbrellas, regardless of type, need "focusing." By adjusting the length of the exposed shaft of an umbrella in a light housing, you can optimize light output. When focusing the umbrella, the modeling light should be on so you can see how much light spills past the umbrella surface. The umbrella is focused when the circumference of the light approximates the perimeter of the umbrella.

Soft boxes are highly diffused and may even be double-diffused with the addition of a second scrim (light-diffusing material) over the lighting surface. Some soft box units accept multiple strobe heads for additional lighting power and intensity. Soft boxes do not have to be focused, since the position of the light within the device housing is optimized for the best effect.

Brian King uses very soft light to photograph his subjects. In combination with some minimal retouching in Photoshop, he produces a very distinctive look based on soft lighting. "I try to keep my lighting simple. I use Photogenic Powerlights. My main light is in an Aurora 7-foot Light Bank, and my fill light is shot into a Westcott 3-foot silver umbrella. Sometimes, I will use a silver reflector for fill instead of the umbrella when I'm photographing real tight head shot images or when I'm using window light. Our window-light area consists of three 3x6-foot windows spaced just under 2 feet apart. I work with my main light in as close as possible. Because of the size of the box and the close location, the catch light (the specular reflection pictured in the iris of the subject's eyes) is large and, most of the time, very subtle."

Hair Light and Background Light. The hair light is placed above and behind the subject. In the past, it was always an undiffused light with barn doors (adjustable metal flaps attached to the light housing to control the width of light emitted). Nowadays, small diffused light sources, such as strip lights, are often used on boom stands or on ceiling-mounted lighting systems to light both the hair and background. The hair light is used primarily to place highlights in the hair, which further increases the illusion of depth and three-dimensionality in the portrait.

A background light is used to illuminate the background so that the subject will separate from it tonally. The background light is sometimes an undiffused light in a reflector with barn doors used on a small stand placed directly behind the subject, out of view of the camera. It may also be a diffused light source placed high and out of the frame on a boom stand, lighting the background from one side (or with two lights, from both sides).

It should be noted that background lights, hair lights, and kickers (another term for lights that are used to illuminate the subject from behind) should not be more intense than the key light. If the key light puts out an exposure of f/8, then the background/hair/kicker light should produce an exposure of f/5.6 or f/4. Otherwise, the lights will overpower the main

▲ Lastolite reflectors are made with a weighted handle so that a photographer working alone on an assignment can maneuver his own reflector easily with one hand. Photograph courtesy of Lastolite from Bogen.
► Mike Colón created this wonderful portrait using filtered sunlight and natural fill bounced off the white wedding dress of the bride (cropped out) who was adjusting the boy's buttons. The lighting ratio is a healthy 3:1. You can see that the strong shadows created by the filtered sunlight are minimized by the close fill-in illumination.

light and destroy the "one light" effect.

Reflectors. Reflectors include any large white, silver, or gold surface that is used to bounce light into the shadow areas of the subject. A wide variety of reflectors is available commercially, including the kind that are collapsible and store in a small pouch. The silver- and gold-foil surfaces provide more light than matte white or translucent surfaces, and the gold-surfaced reflectors are ideal for filling in shadows outdoors, where a warm-tone fill is desirable in shade.

When using a reflector, it should be placed slightly in front of the subject's face. Be careful not to have the reflector beside the face, where it may resemble a secondary main light source coming from the opposite direction of the main light. Properly placed, the reflector picks up some of the main light and wraps it around onto the shadow side of the face, opening up detail in even the deepest shadows.

● BROAD AND SHORT LIGHTING
Broad Lighting. There are two basic types of portrait lighting. Broad lighting means that the key light is illuminating the side of the face that is turned toward the camera (from the camera's perspective,

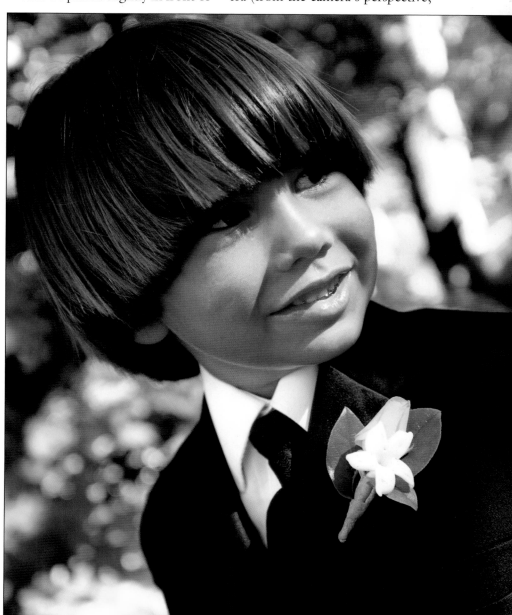

the wider side of the face). Broad lighting is used less frequently than short lighting because it flattens and de-emphasizes facial contours. As described in chapter 9, broad lighting is often used correctively to widen a thin or long face, or to light a thin person.

Short Lighting. Short lighting means that the key light is used to illuminate the side of the face turned away from the camera.

Short lighting emphasizes facial contours, and can be used as a corrective lighting technique to narrow an overly round or wide face. When used with a weak fill light, short lighting produces a dramatic lighting with bold highlights and deep shadows.

With a diffused key light, the differences between broad and short lighting are not as dramatic as with an undiffused key light.

● LIGHTING RATIOS

The lighting ratio describes the difference in intensity between the shadow and highlight sides of the face and is expressed as a ratio—3:1, for example, which means that the highlight side of the face is three times brighter than the shadow side.

Ratios are useful because they determine how much overall contrast there will be in the portrait. They do not determine the scene contrast (the subject's clothing, the background, and the tone of the face determine that), but rather lighting ratios determine the lighting contrast measured at the subject. Lighting ratios indicate how much shadow detail you will have in the final portrait.

Ratios are measured by reading the intensity of the fill light on both sides of the face with a hand-held incident light meter, and then metering the intensity of the key-light side of the face only. If the fill

◄ Fuzzy Duenkel used the beauty of late afternoon sunlight to create this formal portrait of a senior subject playing her harp. The sun, low in the sky, cast good form-flattering light on the subject, while Fuzzy directed a warm-toned reflector in from the left to produce a delicate rim light on her far shoulder and back. Foil reflectors, especially when used with direct light, can be focused to produce an intense highlight, as is seen here.

► This great image by Jerry Ghionis, entitled *Pink*, uses short lighting to describe the beautiful curves and contours of this woman's face. The main light is a single, undiffused light in a reflector which was used without a fill light to produce the classic glamour butterfly lighting pattern. You can see how sharp the light is by counting the shadows from her eyelashes.

▲ **(LEFT)** Deanna Urs created this striking senior portrait in the lobby of a hotel. She noticed a stream of sunlight coming in through the glass ceiling. She asked her young subject to lean her arms on the grand piano. Deanna had her slowly turn her face until the light illuminated her eyes. There is no fill-in source, so the lighting ratio is strong—between 4:1 and 5:1.

▲ **(RIGHT)** Stephen Dantzig created this portrait with a large soft box very close to the model to create the maximum diffusion. A reflector was used on the shadow side of the subject to create a pleasing 3:1 lighting ratio. Stephen also varied the tonality of the image by making most of the image monochromatic in Photoshop, but allowing the lips and eyes to remain in color.

light is next to the camera, it will cast one unit of light on each side (shadow and highlight sides) of the face. The key light, however, only illuminates the highlight side of the face. If the key is the same intensity as the fill light, then you have a 2:1 lighting ratio.

If your fill source is a reflector, you cannot meter light ratios in the manner described above. Extinguishing the key light would also extinguish the fill light. Instead of using an incident meter, which measures the light falling on the subject, it is best to use a reflected light meter, a spot meter, for example, which reads a very narrow angle of view—1 to 5 degrees. You can thus determine the difference in exposure values between the highlight value and the shadow value reading. Decreasing the ratio may mean moving the reflector closer to the shadow side of the subject's face or redirecting the angle of the key light.

A good lighting ratio for color negative film is 3:1 because of the limited tonal range of color printing papers. Black & white films can tolerate up to 8:1, although at this extreme it takes a near-perfect exposure to hold detail in both highlights and shadows.

● **FEATHERING THE LIGHTS**

Lights must be set with sensitivity—even large, forgiving, diffused lights like soft boxes. If you merely aim the light directly at the subject, you may "overlight" the subject, producing pasty highlights with no delicate detail.

You should adjust the key light carefully, and then observe the effects from the camera position. Instead of aiming the light so that

the core of light strikes the subject, "feather" the light so that you employ the edge of the diffused light to illuminate your subject.

The goal is to add brilliance to your highlights. The highlights, when brilliant, have minute specular (pure white) highlights within the main overall diffused highlight. This further enhances the illusion of depth and three-dimensionality in a portrait.

● FASHION LIGHTING

Fashion lighting is a variation on conventional portrait lighting. It is extremely soft and frontal in na- ture, and usually the main light is on the lens–subject axis. Fashion lighting does not model the face, makeup primarily does that. It is a stark lighting that is usually accom- plished with a large soft box direct- ly over the camera and a silver re- flector just beneath the camera. Both the light and the reflector are very close to the subject for the softest effect. When you examine

► Anthony Cava created this memo- rable image of "the old man." In Anthony's words, "He lives across the street from my studio and is affection- ately known as 'Zizi,' which means 'uncle' in Italian." Anthony used a feath- ered grid light on the man's face. Feathering the grid light allowed Anthony to use the dynamic core of the focused light source so that he could selectively light the face, minimizing light on his forehead and hair. Notice the highlight brilliance reminiscent of the great portrait master Yousuf Karsh. No fill light was used in order to let the strong lighting ratio define the texture of this man's incredible skin.

▼ Yervant Zanazanian found it getting late in the day and he had not made what he considered to be an accept- able bridal portrait. He remembered the parking garage, found a vacant carport, and had the bride throw her head up toward the light with one hand on her hip. The result, in one shot, is an award- winning image that still has people buzzing over its uniqueness.

the catchlights in a fashion portrait you will see two—a larger one over the pupil and a less intense one under the pupil. Or sometimes you will see a circular catchlight produced by a ringlight flash—a macrophotography light that mounts around the lens for completely shadowless lighting.

Fashion lighting is a big favorite for girls' senior photography or for a makeover, which involves professional hairstyling and a makeup artist.

When it comes to male fashion portraiture the trend is quite different—you want a bold, dramatic, masculine look. Flat lighting is seldom used with men. Side lighting with hard shadows and very little fill seems to be very popular.

● LOCATION LIGHTING: INDOORS

Balancing Auxiliary and Ambient Light. It will often be necessary to know how to balance the existing light of a scene with auxiliary light you may provide. For instance, you may encounter a scene where you want to preserve the tone and color of the room light, but this existing light is either not sufficient in quantity or quality to make a pleasing portrait. The simple solution is to add light that matches the output of the available light. This is often done with flash or video lights.

With flash, you have to calculate the room exposure with a handheld meter and then match the flash output to the ambient exposure. For instance, if the room light exposure is $\frac{1}{15}$ at f/4, then your flash exposure should match the exposure—$\frac{1}{15}$ at f/4. The room lights will record naturally and the flash, determined to be the same output, will match the room light but light only the subject.

With video lights, you must adjust the distance or output of the light to match the exposure of the ambient light, in the same way you meter for flash.

Window Light. One of the most beautiful types of lighting you can use is window lighting. It is a soft wraparound light that minimizes blemishes, yet it's also a highly directional light, yielding excellent modeling with very low to moderate contrast. The larger the window, or series of windows, the more the light envelops the subject, wrapping the subject in soft, delicate light. Window light also seems to make eyes sparkle exceptionally brightly. Window light is usually a fairly bright light and it is infinitely variable, changing almost by the minute. This

allows you to create a great variety of moods, depending on how far you position your subject from the light.

Since daylight falls off rapidly once it enters a window (it is much weaker several feet from the window than it is closer to the window), care must be taken in determining exposure. You will need to use reflectors to kick light into the shadow side of the face, and you will undoubtedly need an assistant to position the reflector so that you can observe the effects at the camera position. The best window light is the soft light found in the mid-morning or mid-afternoon. Direct sunlight is difficult to work with because of its intensity and because it often creates shadows of the individual windowpanes.

If you find a nice location for a portrait but the light coming through the windows is direct sunlight, you can diffuse the window light by using a large translucent panel or scrim positioned within the window frame. A device made specifically for diffusing window light is a translucent lighting panel, such as the 6x8-foot one made by Westcott. It is collapsible but rigid when extended, and can be leaned into a window sill.

Sunlight diffused in this manner has the warm feeling of sunlight but without the harsh shadows. Since the light is so scattered you may not need a fill source, unless working with several subjects. In that case, use reflectors to kick light back into the face of the person farthest from the window. And because diffused sunlight is often golden in color, a gold-foil-covered reflector is often best in these situations.

● LOCATION LIGHTING: OUTDOORS

Open shade is the shade one finds out in the open from diffused skylight. It has an overhead nature to it and can cause "raccoon eyes"—deep shadows in the eye sockets and under the nose and lower lip. The effects of open shade are the worst at midday, since the sun is directly overhead. It is often difficult to discern how bad the light is in these situations, because your eye tends to adapt to what it perceives as soft lighting.

The best shade for portraiture is found in or near a clearing, where tall trees provide an overhang above the subjects, thus blocking the overhead light. At the edge of such a clearing, diffused light filters in from the sides, producing better modeling on the face than in open shade. If no natural overhead obstruction exists, consider using an overhead gobo.

Gobos. Gobos (or black flags, as they're sometimes called), are opaque black panels that are used as light blockers. In the studio, they are usually used to shield a part of the subject from light. In the field, they are often used to block overhead light when no natural overhead obstruction exists. This reduces the overhead nature of the lighting, minimizing the darkness under the eyes and, in effect, lowering the angle of the main light source so that it is more of a sidelight.

▲ (LEFT) Monte Zucker created this lovely portrait using fashion lighting. You can see in the catchlights the over/under configuration of the lights—one above the camera, one below—which produces the frontal lighting that is virtually shadowless. It is important when using fashion-type lighting that makeup be expertly applied since the makeup, not the lighting, accomplishes the contouring of the face.

▲ (RIGHT) Using a video light held by his assistant, Yervant Zanazanian created this wonderful portrait of a pensive bride with a cigar. Notice the proper exposure of all the lights within the scene. Also note the beautiful S curve of the bride, shaping the composition.

► Window light, the softer the better, is ideal for a beautiful sleeping baby. Elizabeth Homan created this wonderful portrait with beautiful soft light from a large window and further enhanced the softness of the image and light in Photoshop.

Scrims. Scrims are a means of diffusing light. In the movie business, huge scrims are suspended like sails on adjustable flats or frames and positioned between the sun (or a bank of lights) and the actors, diffusing the light over the entire set. A scrim works the same way a diffuser in a soft box works, misdirecting (softening) the light that shines through it.

Monte Zucker has perfected a system of using large scrims—3 x 6 feet and larger. With the sun as a backlight, he has several assistants hold the translucent light panel above the subject so that the backlighting is instantly diffused. In front of the subject he will use a reflector close to the subject to bounce the diffused backlight onto the subject or subjects. The effect is very much like an oversized soft box used close to the subject for heavily diffused, almost shadowless light.

Fill Light. If forced to shoot in unobstructed open shade (and this is not always a bad thing—the location and background might be perfect), you will need to fill in the diffused daylight with a frontal flash or reflector. If you want to use a reflector, choose a large silver one and place it close to the subject and slightly below head height. Then, wiggle it back and forth and watch the shadows open up as light strikes these areas.

More reliable than reflectors for fill-in illumination is electronic flash. If using flash, the output should be at least one stop less than the ambient light exposure reading, in order to fill and not overpower the daylight. For this purpose, a great many portrait photographers use barebulb flash, a portable flash unit with a vertically positioned flash tube that fires the flash a full 360 degrees. You can use your widest wide-angle lenses and you won't get flash fall-off with barebulb flash, since there is no flash reflector limiting the angle of its beam of light. Barebulb

flash produces a sharp, sparkly light, which is too harsh for almost every type of photography except outdoors. The trick is not to overpower the daylight. This is the best source of even fill-in illumination.

Another popular flash-fill system involves using on-camera TTL flash. Many on-camera TTL flash systems offer a fill-light mode that will automatically balance the flash output to the ambient-light exposure. These systems are variable, allowing you to dial in full- or fractional-stop output adjustments for the desired ratio of ambient-to-fill illumination. They are great sys-

tems and more importantly, they are reliable and predictable. Some of these systems also allow you to use the flash off-camera with a TTL remote cord.

To determine the correct exposure with fill flash, begin by metering the scene. It is best to use a handheld incident flash meter, with the meter's hemisphere (the dome) pointed at the camera from the subject position, and the meter in ambient mode. Let's say the metered exposure for the daylight is $\frac{1}{15}$ at f/8. Now, with the meter in flash-only mode, meter just the flash. Your goal is for the flash output to be one stop less than the ambient exposure. Adjust flash output or flash distance until your flash reading is f/5.6. Set the camera and lens to $\frac{1}{15}$ at f/8.

If the light is dropping or the sky is brilliant in the scene and you want to shoot for optimal color saturation in the background, overpower the daylight exposure with flash. In the same hypothetical situation where the daylight exposure was $\frac{1}{15}$ at f/8, now adjust your flash output or flash distance so your flash meter reading is f/11, a stop more powerful than the daylight. Set your camera to $\frac{1}{15}$ at f/11. The flash is now the key light and the soft twilight is the fill light. The only problem with this is that

▶ To create this beautiful backlit image of a bride, Bill Duncan used a Mamiya RB-67 and a 250mm lens that allowed him to blur the background a bit. He used Kodak Portra 400 VC film and fired a flash at about two stops less than the ambient light exposure. He wanted to guarantee that the shadows would be filled. The image was made just before sunset.

you will get a separate set of shadows from the flash. This can be acceptable, however, since there aren't really any shadows from the twilight.

It is also important to remember that you are balancing two light sources in one scene. The ambient light exposure will dictate the exposure on the background and the subject. The flash exposure only affects the subject. When you hear of photographers "dragging the shutter" it refers to using a shutter speed slower than X-sync speed in order to expose the background properly. Understanding this concept is the essence of good flash-fill.

With in-lens blade-type shutters, flash sync occurs at any shutter speed because there is no focal plane shutter curtain to cross the film plane.

If using a focal-plane shutter as found in 35mm SLRs, however, you have an X-sync shutter speed setting. You cannot use flash with a shutter speed faster than the X-sync speed. Otherwise, your photos will be only partially exposed by the flash. You can, however, safely use any shutter speed slower than the X-sync speed with flash. Your strobe will fire in synchronization with the shutter, and the longer shutter speed will build up the ambient light exposure.

CHAPTER NINE
CORRECTIVE POSING TECHNIQUES

This chapter deals with practical ways to idealize the subject. It is important to realize that people don't see themselves the way others do. Subconsciously, they shorten their own noses, imagine they have more hair than they really do, and in short, pretend they are better-looking than they really are. A good portrait photographer knows this and acts on it the instant a person arrives. It is a matter of procedure; the photographer analyzes the face and body and makes mental notes as to how best to light, pose, and compose the subject to produce a flattering likeness.

○ SOFT FOCUS AND DIFFUSION

Skin problems are the most frequent physical problem the portrait photographer encounters. Young subjects have generally poor skin, often with blemishes or pockmarks. Older subjects have wrinkles, age lines, and age spots. In subjects of all ages, the effects of aging, diet, and illness are mirrored in the face.

Soft focus or diffusion can be used to minimize facial defects and can instantly take years off an elderly subject. Softer images are often more flattering than portraits in which every facial detail is visible. Soft-focus images have also come to connote a romantic mood in portraits and pictorial photography.

There are four ways to diffuse the image for soft-focus effects. First, you can use a soft-focus lens, designed to produce a sharp image point surrounded by an out-of-focus halo. These lenses produce this effect because they are uncorrected in some degree for spherical aberration, one of the

▲ Soft light and soft focus combine to create an idealized image devoid of any facial irregularities like wrinkles. Here Monte Zucker used a Canon EOS 10D and an EOS 135mm f/2.8 soft-focus lens to create the image. Two soft lights were used—a key light, which creates a lovely loop-lighting pattern, and a fill light, which opens up the beautiful lines on the shadow side of her face and the beautiful details of her neck and shoulders.

major aberrations lenses can suffer from. Soft-focus lenses do not produce out-of-focus images; rather, they give a sharp image with an out-of-focus halation around the image point. With soft-focus lenses, the soft-focus effect is diminished by stopping down the lens. Therefore, the lens is used wide open, close to or at its maximum aperture for the softest image.

The second means of diffusing an image is with a diffusion filter. These blend the highlights of the image into the shadow areas by diffusing the light rays as they pass through the filter. Soft-focus or diffusion filters come in degrees of softness and are often sold in sets with varying degrees of diffusion.

The third method is to diffuse the negative in printing. This has the opposite effect of on-camera diffusion, and blends shadows into highlights. Unfortunately, this sometimes produces muddy prints with lifeless highlights, depending on the technique, time of diffusion, and material used.

A final method of diffusion is done using Photoshop. The diffusion techniques are quite varied in Photoshop, allowing you to selectively soften the image, which permits great flexibility and control.

● RETOUCHING

Part of the pleasure of purchasing a fine portrait is the invisible retouching that has been done to the final image. Retouching is expected in a fine portrait and when a customer sees unretouched proofs, they will, of course, recognize that certain aspects of their appearance "need work."

The retouching that is done today differs greatly from that done only a few years ago. In comparing traditional retouching with today's digital retouching, master photographer Frank Frost states, "The difference is like night and day. We can digitally retouch an entire order in the time it used to take us to retouch just a couple of negatives." Retouching is now done to the digital file and the image is conveniently worked as a positive, so that what you see is what you get.

When retouching an image in Photoshop, you can enlarge any portion of the photograph up to 1600 percent, so every small detail in the image can be reworked. A variety of brushes, pencils, and erasers can be selected and the opacity and transparency of each can be easily adjusted in minute increments. Photoshop also allows you to select an area you want to retouch, ensuring that any changes will apply only to that selection.

Photoshop also has amazing tools, such as the healing brush,

▼ Brian King is also a wiz at subtle retouching in Photoshop. Although seniors usually have questionable complexions, with a combination of very soft light and a deft hand in Photoshop, King ensures a perfect complexion. Unlike the retouching of old, this does not render the face devoid of details.

which allows you to clone an adjacent area of the image complete with lighting angles and textures. Take, for instance, the lines under a person's eyes. With the healing brush, you can sample the smooth area under the lines, then apply the smooth area to the wrinkled area, gradually wiping out the irregular-

ities. Blemishes are so simply removed it's almost laughable—especially compared to the work that went into that operation in the conventional retoucher's studio.

Retouching, in Photoshop or with leads and dyes, is a function of blending any uneven densities throughout the image. A blemish

or age spot or wrinkle is darker or lighter than the surrounding area of the image. At high magnification, the retoucher blends those areas with surrounding tones to diminish their visibility. Another way this is done is to introduce selective diffusion into those areas. Photoshop offers a smudge tool that allows you to break up crisp lines, such as wrinkles, with a tool that acts like a fingertip on charcoal, blending the affected area until it is restored.

Not only can facial irregularities be eliminated digitally, but drastic retouching tasks, like swapping the head from one pose and placing it on another, are a matter of routine—just select, copy, and paste. There is almost no end to the complex effects that can be produced digitally.

● CORRECTING
SPECIFIC PROBLEMS
This section deals with methods to correct specific physical traits you will encounter with everyday people. Remember to be tactful about making suggestions.

Overweight Subjects. Have an overweight subject dress in dark clothing, which will make him or her appear ten to fifteen pounds slimmer. It can also help to use a pose in which the subject is turned at a 45-degree angle to the camera. Never photograph a larger person head-on or in a seven-eighths-view.

Use a low-key lighting ratio and use short lighting so that most of the subject is in shadow, The higher lighting ratios that produce low-key lighting will make your subject appear much slimmer. Use

▲ Deborah Lynn Ferro often uses creative Photoshop techniques to minimize retouching. The levels control in Photoshop allows you to shift the tonal scale toward the shadows or highlights. Shifting the tonal scale toward the highlights blows out the bright areas to almost a paper white—a very trendy fashion technique. Deborah also likes to apply a charcoal effect in Photoshop.

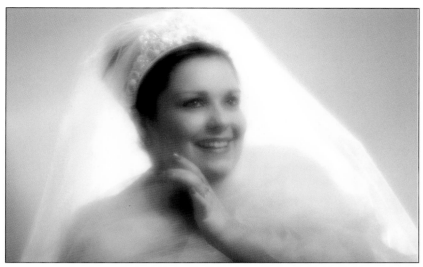

▲ **(LEFT)** Larry Peters used soft focus and vignetting as well as a pose that makes it impossible to tell the size and shape of his young subject. A formal dress bunched up makes it impossible to see her waist, and thus you assume she is 105 pounds and has a perfect figure. This is probably the case, as Larry photographs a lot of seniors, but it may not necessarily be so.

▲ **(RIGHT)** Monte Zucker used soft light and a soft focus lens to diffuse the image, and broke it into halves with the bride's upraised hand, which is both elegant and functional. The bride is heavily backlit so that her shoulders merge with the high key background. Notice too that Monte used short lighting with a healthy ratio even though this is basically a high key shot.

a dark-colored background and, if possible, try to merge the tone of the background with that of the subject's clothes. To do this, you must either minimize or eliminate the background light, and eliminate any kickers you might use to highlight the shadow-side edge of the subject.

It is best to have large people standing in the photograph. Seated, the excess weight accumulates around their middles. A dark vignette at the bottom of the portrait is another trick to minimize the appearance of extra weight.

Underweight Subjects. A thin person is much easier to photograph than an overweight person. Have the person wear light-colored clothing and use a high-key lighting ratio and light-colored background. When posing a thin person, have him or her face the camera more to provide more width. A seven-eighths-pose is

ideal for people who are on the thin side.

If the person is extremely thin, do not allow him or her to wear sleeveless shirts or blouses. For a man, a light-colored sports coat will help fill him out; for a woman, fluffy dresses or blouses will disguise thin arms.

For a thin face, use broad lighting and a fairly low lighting ratio in the 2:1 or 3:1 range. Use broad lighting in which the side of the face turned toward the camera is highlighted, making the face appear wider. The general rule is, the broader the person's face, the more of it should be kept in shadow; the narrower the face, the more of it should be highlighted—the basic difference between broad and short lighting.

Elderly Subjects. The older the subject, the more wrinkles he or she will have. It is best to use some type of diffusion, but do not

soften the image to the point that none of the wrinkles are visible. Men, especially, should not be overly softened as their wrinkles are considered "character lines."

You should use a frontal type of lighting so that there are no deep shadows in the wrinkles and deep furrows of the face. Using a softer, diffused type of lighting such as umbrella light will also help to de-emphasize wrinkles.

A smaller image size is also called for in photographing elderly people. Even when making a head-and-shoulders portrait, the head size should be about 10–15 percent smaller, so that facial irregularities are not as noticeable.

Baldness. If your subject is bald, lower the camera height so less of the top of his head is visible. Use a gobo between the main light and the subject to shield the bald part of his head from light. Another trick is to feather the main

◄ Jeff Smith knows how to pose his kids so that they look like a million bucks. Here, two posing tricks are in effect. Even though this svelte senior doesn't need it, her hips and waist are hidden behind foreground foliage. Also, she is rolled onto her hip so that any stray weight is out of the view of the lens.

► Deanna Urs is conscious of photographing her subjects at their very best. This image of two senior girls was made at the local coffee shop. The posing of one girl in front of the other slims the figure of the back girl. The girl in the foreground is hidden by her book and her knees raised high, making her face and eyes the focal point.

light so that the light falls off rapidly on the top and back of his head. The darker in tone the bald area is, the less noticeable it will be. Do not use a hair light, and use a minimal background light. If possible, try to blend the tone of the background with the top of your subject's head.

Double Chins. To reduce the view of the area beneath the chin, raise the camera so that area is less prominent. Tilt the chin upward and raise the main light so that much of the area under the chin is in shadow. You should also keep the light off the subject's underchin area, using a gobo between the light and subject if necessary.

Broad Foreheads. To diminish a wide or high forehead, lower the camera height and tilt the person's chin upward slightly. If you find that by lowering the camera and raising the chin, the forehead is only marginally smaller, move the camera in closer and observe the effect again.

Deep-Set or Protruding Eyes. To correct deep-set eyes, keep the main light low to fill the eye sockets with light. Keep the lighting ratio low so there is as much fill light as possible to lighten the eyes. Raising the chin will also help diminish the look of deep-set eyes. To correct protruding eyes, raise the main light and have the person look downward so that more of the eyelid is showing.

Large Ears. To scale down large ears, the best thing to do is to hide the far ear by placing the person in a three-quarter pose, making sure that the near ear is in shadow, either by using a gobo to block the light from hitting the ear or by feathering the main light. If the subject's ears are very large, examine the person in a profile pose. A profile pose will totally eliminate the problem.

Dark Skin Tones. Unusually dark skin tones must be compensated for in exposure if you are to obtain a full tonal range in the portrait. For the darkest skin tones, open up a full f-stop over the indicated meter reading. For moderately dark subjects, like deeply suntanned people, open up one-half stop over the indicated exposure.

Uneven Mouths. If your subject has an uneven mouth (one side higher than the other, for example) or a crooked smile, turn the subject's head so that the higher side

of the mouth is closest to the camera, or tilt the head so that the line of the mouth is more or less even.

Long Noses and Short Noses. To correct for a subject with a long nose, lower the camera height and tilt the chin upward slightly. Lower the key light so that if you have to shoot from much below nose height, there are no deep shadows under the nose. You should use a frontal pose, either a full-face- or seven-eighths-view, to disguise the length of your subject's nose.

For a short nose, raise the camera height to give a longer line to the person's nose. Have the subject look downward slightly and try to place a specular highlight along the ridge of the nose. The highlight tends to lengthen a short nose even more.

Long Necks and Short Necks. While a long neck can be considered sophisticated, it can also appear unnatural, especially in a head-and-shoulders portrait. By raising the camera height, lowering the head, keeping the neck partially in shadow, and pulling up the shirt or coat-collar, you will shorten an overly long neck. If you see the subject's neck as graceful and elegant, back up and make a three-quarter- or full-length portrait to emphasize the graceful line of the neck in the composition.

For short necks, place light from the main light on the neck. This is accomplished by lowering the main light or feathering it downward. Increase the fill light on the neck so there is more light on the shadow side of the neck. Lowering the camera height and suggesting a V-neck collar will also lengthen a short neck.

Wide Mouths and Narrow Mouths. To reduce an overly wide mouth, photograph the person in three-quarter view, not smiling. For a narrow mouth, photograph the person in a more frontal pose and have him or her smile broadly.

Long Chins and Stubby Chins. Choose a higher camera angle and turn the face to the side to correct a long chin. For a stubby chin, use a lower camera angle and photograph the person in a frontal pose.

Oily Skin. Oily skin looks shiny in a portrait. If you combine oily skin with sharp, undiffused lighting, the effect will be unsettling. Always keep a powder puff and a tin of face powder on hand to pat down oily areas. The areas to watch are the frontal planes of the face—the center of the forehead, the chin, and the cheekbones. Oily skin can also be minimized by using a diffused main light, such as an umbrella or soft box.

◄ Remember point of view when making a head-and-shoulders portrait. Here Brian King used a high vantage point—above eye height—and you can see the effects of the changed perspective. The forehead is broad while the chin is narrow. Brian raised the camera angle so that the young subject could look up at the camera, thus revealing the teenager's intense eyes.

Dry Skin. Dry skin looks dull and lifeless in a portrait. To give dry skin dimension, use an undiffused main light. If it still looks dull, use a little hand lotion or body oil on the person's face to create small specular highlights in the skin. Don't overdo it with the lotion or oil, or you will have the reverse problem—oily skin.

Scars and Discoloration. Facial characteristics like scars and discoloration are best disguised by placing them in shadow, using a short-lighting setup and a strong lighting ratio.

● **BE DISCRETE**

There are some problems you may not have thought of when it comes to correcting facial irregularities. First, what if the person is proud of the trait you consider a difficulty? Second, what should you do when you encounter more than one problem?

The first question is best settled in a brief conversation with your subject. You can comment on his or her features by saying something like, "You have large, bright eyes, and the line of your nose is quite elegant." If the person is at all self-conscious about the traits you mentioned, he or she will usually say something like, "Oh, my nose is too long, I wish I could change it." Then you know that the person is unhappy with their nose, but happy with his eyes—and you know how to proceed.

The second question is a little more difficult. It takes experience before you can quicky discern which of the facial problems is the more serious one and most needs

▲ This portrait by Brian King displays a combination of high camera angle and low angle of gaze. Still, the subject exudes an exotic beauty and mystery. The high camera angle narrowed the chin and broadened the forehead.

correcting. Generally, by hand-holding the camera and moving into the corrective positions, you can see how the irregularities are changed. By experimenting with various lighting, poses, and camera angles, you should be able to come up with the best compromise. This takes experience, so learn the corrective techniques outlined in this chapter, and practice them often so that when you are faced with a real

dilemma, your judgment will be sound.

More than good lighting, posing, and composition techniques, the successful portrait photographer knows how to deal with the irregularities of the human face and body. All of the great portrait photographers know that their success lies in being able to take the ordinary in people and make it extraordinary.

CHAPTER TEN
PORTRAIT GALLERY

These portraits, from a variety of great portrait photographers, represent the very best in contemporary portraiture and contemporary posing. The images are by photographers from around the world and are noteworthy for a variety of reasons, including breaking the rules. Experts know when the rules should be broken for effect and when they should be adhered to.

▲ Joe Buissink is a master at uncovering gorgeous poses, as was done here in the blink of an eye as this beautiful woman peeked out from the window of her limo. This image was made with a Nikon D1X, 80–200mm f/2.8 lens at the 60mm setting.

► The winding country road, a beautiful curved compositional line, is the backdrop for this senior portrait by Fuzzy Duenkel. The background and foreground have been diffused in Photoshop so that we may concentrate on the "journey" of the teen, who is serious, strong, and upright in his pose, as if determined to successfully complete the trip.

▼ (LEFT) Fran Reisner re-created this image from a conversation she had with her videographer, who described how his three-year-old helps him edit wedding videos, dreaming of the day that she will be a bride. Fran found the adult bride to come in and model for this image, then the two images were combined in Photoshop and the watercolor effect was done in Painter. Note: the shoes, bears, and tiara in the portrait belong to the little girl. It is one of her favorite storytelling images.

▼ (RIGHT) This classic pose was made by Bill Duncan. In his words, "I asked the groom to dip the bride in a Fred Astaire—type pose. No additive-light was used; just plain old sunset/twilight, and the beautiful lighting ratio on their faces is completely natural, with no flash or reflectors. I do not take images that look stiff or that make people look like trees. The exposure here was $\frac{1}{60}$ at f/5.6. You can add softening after the shot to make it more dreamy or surreal. Sometimes you must go where nobody has gone previously to make your photos work for you—dare to be different, as someone once said."

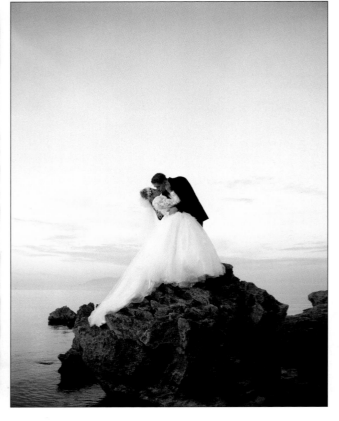

▲ **(LEFT)** Giorgio Karayiannis made this incredibly vibrant and emotional portrait, completely devoid of facial detail. The portrait is called *Imam*, the name for a male spiritual leader regarded by Muslims as a descendant of Muhammad, divinely appointed to guide human beings. The rounded curve of the shoulders symbolizes the earthly weight that rests on this spiritual leader. The glow of green behind him symbolizes hope. The image was made with a Canon EOS D60 and 70—210mm EOS lens at an exposure of ⅛ at f/4.3.

▲ **(RIGHT)** Giorgio Karayiannis produced this image of a client who has cancer. The image was so well received that various organizations are now using it to provide inspiration to cancer patients all over Australia. The combination of the mystical pose and the clean, smooth tones throughout make this an arresting image.

◄ This image was created by Deanna Urs and titled *The Piano*. In Deanna's words, "These were two cousins—one and two-year olds. This image was made at the end of a shoot outdoors. I loved this room and its architecture. It was a stark room—simply appointed. I turned on the lights in the ceiling to enhance the line of the ceiling. I previsualized this to be a black & white image, and I knew I would get this beautiful glow from the overhead lights. I thought how cute it would be to have these babies at the piano, and I wanted to have a whimsical feel, so I chose to have the toddlers pose *au naturel*. I made this image with a Canon digital camera and 28—70mm lens."

► If you want to test your posing skills, try working with animals. Tammy Loya managed to get her bulldogs to behave with a few well-behaved squeaky toys nearby. Dogs look most animated when their ears are forward, giving them an inquisitive expression.

▲ An image like this is more a result of a great eye and good planning than it is of intentional posing. Kevin Kubota saw the relationship between cowboy and longhorns and placed himself and the striding cowboy in perfect position to make this humorous image. A Nikon D1X and 80—200mm f/2.8 Nikkor lens at the 200mm setting were used to make the image.

◄ Michael Taylor connects with his subjects, and it's visible in every portrait he makes. Here, the artist in the image frames and composes the artist making the image—an ironic twist. The unusual pose reveals the hands of the artist in a way one would probably never pose someone, other than an artist or craftsman. Michael Taylor's portraits also exhibit a consistent rule breaker—he likes to pose his subjects with their shoulders square to the camera, to increase the feeling of directness.

► *So You're the New Boy, Eh?* That's the title of this amazing historically accurate portrait by David Williams. In the photographer's words, "This character represents a rather formidable and malevolent Dickensian clerk. I tried to imagine being the small, undernourished, and maltreated boy coming along for the job." The pose is made more intimidating by the squint in the eye, the lean forward at the waist, and the head cocked in a confrontational manner.

▶ (TOP) Photographer Frank Frost surrounded this cherubic face with props and her favorite thing, her bear, and made a shy little girl happy. If you notice, she is "hiding" behind things; it is no doubt due to her shyness. Frank used elegant diffused lighting with a delicate hair light and subtle background light to refine the portrait. For little children, a photo studio can be an intimidating place. That's why it's always good to have a meeting with the parent and child prior to the portrait, so they can get familiar with this different place.

▶ (BOTTOM) The title of this remarkable photograph by Fran Reisner is *Age of Innocence*. The mother of this five-year-old child wanted to capture her daughter at this age for a portrait to hang over their mantel. Fran asked Mom to close her eyes and imagine Alex playing by herself. She saw her playing with her dolls. During the course of the conversation Fran discovered that Mom still had her own doll cradle from childhood. That and her bridal veil added emotional value to the image. The oil-painting effect, created in Painter, gives the image a richer, more traditional look, suitable for a formal living room. The image was made with a Mamiya RZ-67, 180mm lens, and Kodak Portra 400VC film, using window light in the studio.

◀ Good posing is like good design; it doesn't call attention to itself. In this senior portrait by James C. Williams, relaxed elegant posing and beautiful lighting help make a memorable image. Her hands are relaxed and, although she is leaning into the wall, her weight is not compressing her arms into her body. A slight space between her right arm and body makes her look thin and fit. And, like a model, she is thin enough to be posed head-on without much of a shoulder turn. Here is some information from the photographer: "To make this pose look good it's important that the subject's head is tilted in the opposite direction of the shoulder in the lower position. Also notice how the subject's hip is out slightly; this, of course, creates a nice S curve on the subject, which is very pleasing to the eye."

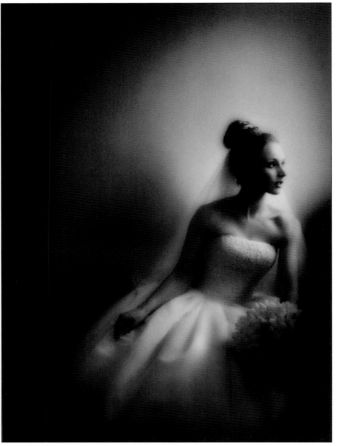

▲ (LEFT) A flawless image of the bride with an almost *Mona Lisa*—like smile was captured reflected into a compact mirror. Yervant Zanazanian made the image with a Canon D60, 70—210mm lens, and an 800 ISO setting. Yervant describes the shot: "We were in a bar having drinks after the church [an Australian custom], and the bride was adjusting her makeup so that we could continue location shooting. I saw the moment and captured it. I lit the shot with a video light, held by my assistant. I did the retouching using Photoshop."

▲ (RIGHT) This gorgeous, off-center portrait was created by Martin Schembri. Elegant lighting with a strong lighting ratio helped define this dramatic image. As she leans out of frame, a very uncharacteristic pose, a powerful diagonal line is created. By using more space behind her than in front of her (an unusual posing tactic), a feeling of visual tension is created. The dark areas behind the bride are balanced by the highlighted wall behind her. Schembri used a combination of filters and lighting effects in Photoshop that not only make the image more contrasty and sepia toned, but also "smeared" shadow areas for a painterly diffusion.

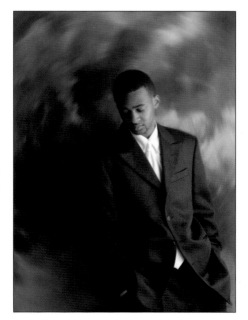

► (RIGHT) A refined senior portrait made by Brian King is turned into an edgy treatment by tilting the camera (to provide a stronger diagonal line) and then using radial blur in Photoshop to provide a spinning effect to the background. As a result, what originally would have been a pleasing formal portrait is rendered in a style that appeals more to the senior pictured.

► (FACING PAGE) Expert senior photographer Larry Peters created this lovely senior portrait, adding dynamic lines to the composition by having the girl lean slightly toward her low shoulder. The pose is intense and non-smiling, but not unpleasant. Seniors seem to prefer edgy posing, which is more reflective of their emerging personalities. The wild hair and hidden left eye are all part of this image's drama and mystery.

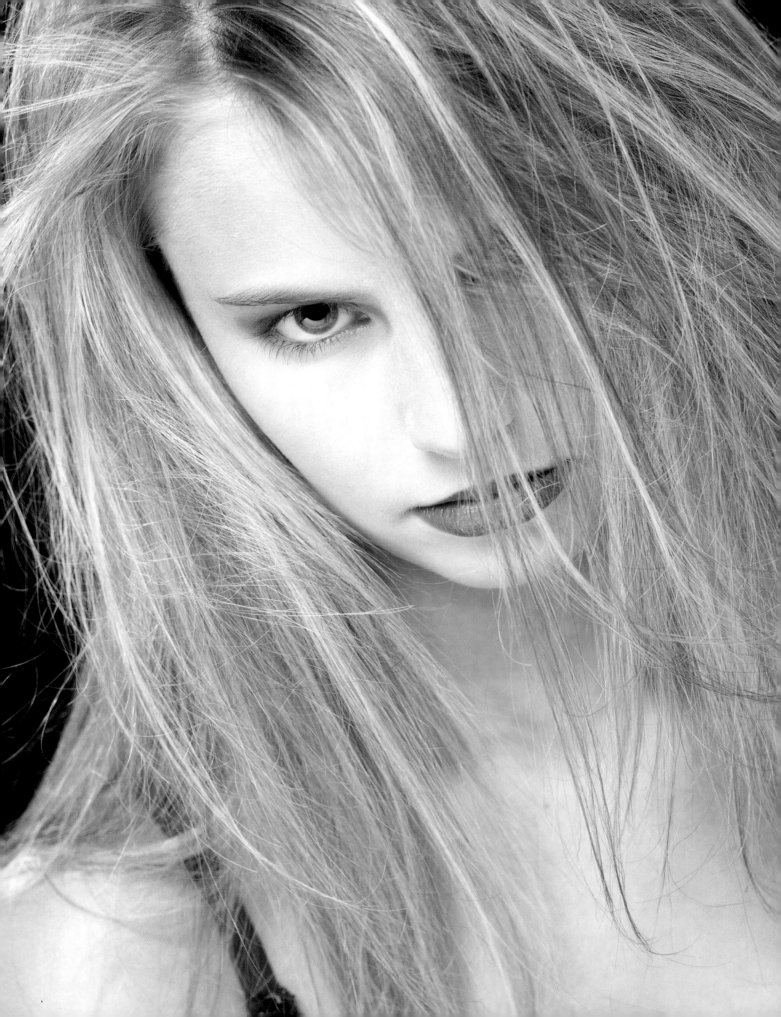

GLOSSARY

Balance. A state of visual symmetry among elements in a photograph.

Broad Lighting. One of two basic types of portrait lighting in which the key light illuminates the side of the subject's face turned toward the camera.

Depth of Field. The distance that is sharp beyond and in front of the focus point at a given f-stop.

Depth of Focus. The amount of sharpness that extends in front of and behind the focus point. Some lenses' depth of focus extends 50 percent in front of and 50 percent behind the focus point. Other lenses may vary.

Fashion Lighting. Type of lighting that is characterized by its shadowless light and its proximity to the lens axis. Fashion lighting is usually head-on and very soft in quality.

Feathering. Misdirecting the light deliberately so that the edge of the beam of light illuminates the subject.

Feminine Pose. A pose characterized by the head tilted toward the high shoulder.

Fill Light. Secondary light source used to fill in the shadows created by the key light.

Foreshortening. A distortion of normal perspective caused by close proximity of the camera/lens to the subject. Foreshortening exaggerates subject features—noses appear elongated, chins jut out, and the backs of heads may appear smaller than normal.

45-Degree Lighting. A portrait lighting pattern that is characterized by a triangular highlight on the shadow side of the face. Also known as Rembrandt lighting.

Full-Length Portrait. A pose that includes the full figure of the model. Full-length portraits can show the subject standing, seated, or reclining.

Furrows. The vertical grooves in the face adjacent to the mouth. Furrows are made deeper when the subject smiles; often called laugh lines.

Gobo. Light-blocking card that is supported on a stand or boom and positioned between the light source and subject to selectively block light from portions of the scene. Also known as a black flag.

Head-and-Shoulder Axis. Imaginary lines running through shoulders (shoulder axis) and down the ridge of the nose (head axis). The head and shoulder axes should never be perpendicular to the line of the lens axis.

Key Light. The main light in portraiture used to establish the lighting pattern and define the facial features of the subject.

Kicker. A back light (a light coming from behind the subject) that highlights the hair or contour of the body.

Lead-in Line. In compositions, a pleasing line in the scene that leads the viewer's eye toward the main subject.

Lighting Ratio. The difference in intensity between the highlight side of the face and the shadow side of the face. A 3:1 ratio implies that the highlight side is three times brighter than the shadow side of the face.

Main Light. Synonymous with key light.

Masculine Pose. A pose characterized by the head tilted toward the low shoulder.

Modeling Light. A secondary light mounted in the center of a studio flash head that gives a close approximation of the lighting that the flash tube will produce. Usually high intensity, low-heat output quartz bulbs.

Perspective. The appearance of objects in a scene as determined by their relative distance and position.

Reflector. (1) A deviced that is used to bounce light onto a subject or scene. Also called a fill card. (2) A housing on a light that reflects the light outward in a controlled beam.

Rule of Thirds. Format for composition that divides the image area into thirds, horizontally and vertically. The intersection of two lines is a dynamic point where the subject should be placed for the most visual impact.

Seven-Eighths View. Facial pose that shows approximately seven-eighths of the face. Almost a full-face view as seen from the camera.

Shadow. An area of the scene on which no direct light is falling, making it darker than areas receiving direct light.

Short Lighting. One of two basic types of portrait lighting in which the key light illuminates the side of the face turned away from the camera.

Soft-Focus Lens. Special lens that uses spherical or chromatic aberration in its design to diffuse the image points.

Three-Quarter-Length Pose. Pose that includes all but the lower portion of the subject's anatomy. Can be from above the knees and up, or below the knees and up.

Three-Quarter View. Facial pose that allows the camera to see three-quarters of the facial area. The subject's face is usually turned 45 degrees away from the lens so that the far ear disappears from camera view.

Tension. A state of visual imbalance within a photograph.

Triangle Base. The combination of head, torso, and arms that form the basic compositional form in portraiture.

Two-Thirds View. A view of the face that is between a three-quarter and seven-eighths view. Many photographers do not recognize these distinctions—anything not a head-on facial view or a profile is a two-thirds view.

Wraparound Lighting. A soft type of portrait light produced by umbrellas that wraps around the subject to produce a low lighting ratio and open, well-illuminated highlight areas.

X-Sync Speed. The shutter speed at which focal-plane shutters synchronize with electronic flash.

INDEX

MASTER COMPOSITION
GUIDE FOR DIGITAL PHOTOGRAPHERS

Ernst Wildi

Composition can truly make or break an image. Master photographer Ernst Wildi shows you how to analyze your scene or subject and produce the best-possible images. $34.95 list, 8.5x11, 128p, 150 color photos, index, order no. 1817.

PROFESSIONAL PORTRAIT LIGHTING
TECHNIQUES AND IMAGES FROM MASTER PHOTOGRAPHERS

Michelle Perkins

Get a behind-the-scenes look at the lighting techniques employed by the world's top portrait photographers. $34.95 list, 8.5x11, 128p, 200 color photos, index, order no. 2000.

MASTER POSING GUIDE
FOR CHILDREN'S PORTRAIT PHOTOGRAPHY

Norman Phillips

Create perfect portraits of infants, tots, kids, and teens. Includes techniques for standing, sitting, and floor poses for boys and girls, individuals, and groups. $34.95 list, 8.5x11, 128p, 305 color images, order no. 1826.

MASTER'S GUIDE TO WEDDING PHOTOGRAPHY
CAPTURING UNFORGETTABLE MOMENTS AND LASTING IMPRESSIONS

Marcus Bell

Learn to capture the unique energy and mood of each wedding and build a lifelong client relationship. $34.95 list, 8.5x11, 128p, 200 color photos, index, order no. 1832.

MASTER LIGHTING GUIDE
FOR COMMERCIAL PHOTOGRAPHERS

Robert Morrissey

Use the tools and techniques pros rely on to land corporate clients. Includes diagrams, images, and techniques for a failsafe approach for shots that sell. $34.95 list, 8.5x11, 128p, 110 color photos, 125 diagrams, index, order no. 1833.

SOFTBOX LIGHTING TECHNIQUES
FOR PROFESSIONAL PHOTOGRAPHERS

Stephen A. Dantzig

Learn to use one of photography's most popular lighting devices to produce soft and flawless effects for portraits, product shots, and more. $34.95 list, 8.5x11, 128p, 260 color images, index, order no. 1839.

JEFF SMITH'S LIGHTING FOR OUTDOOR AND LOCATION PORTRAIT PHOTOGRAPHY

Learn how to use light throughout the day—indoors and out—and make location portraits a highly profitable venture for your studio. $34.95 list, 8.5x11, 128p, 170 color images, index, order no. 1841.

PROFESSIONAL PORTRAIT POSING
TECHNIQUES AND IMAGES FROM MASTER PHOTOGRAPHERS

Michelle Perkins

Learn how master photographers pose subjects to create unforgettable images. $34.95 list, 8.5x11, 128p, 175 color images, index, order no. 2002.

MONTE ZUCKER'S PORTRAIT PHOTOGRAPHY HANDBOOK

Acclaimed portrait photographer Monte Zucker takes you behind the scenes and shows you how to create a "Monte Portrait." Covers techniques for both studio and location shoots. $34.95 list, 8.5x11, 128p, 200 color photos, index, order no. 1846.